SO-BFB-595

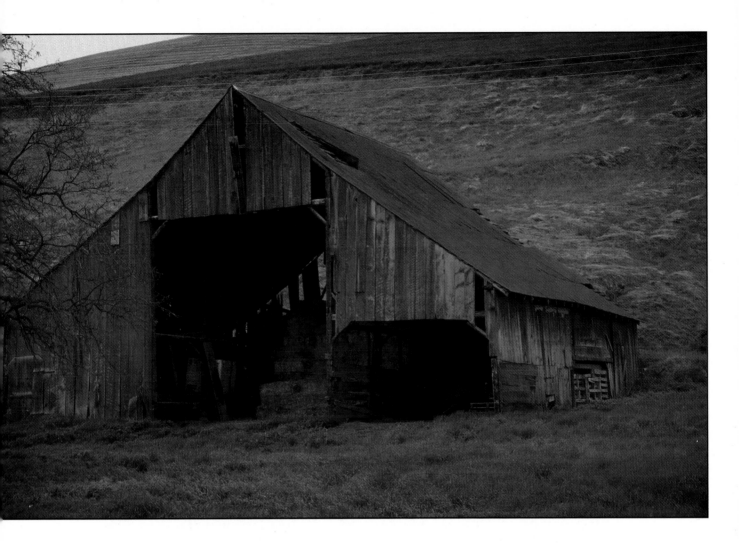

BARNS of the WEST

A Vanishing Legacy

ARTHUR A. HART

HISTORIC IDAHO, INC.

HISTORIC IDAHO, INC.

Boise, Idaho

1996

Printed in the United States of America
by Capitol Lithograph & Printing
Boise, Idaho
Typography by B & J Typesetting

Library of Congress Cataloging in Publication Data

Hart, Arthur A., 1921-

Barns of the West: a Vanishing Legacy/ Arthur A. Hart
Library of Congress Catalog Card No. 96-85319

ISBN 0-9631258-9-3

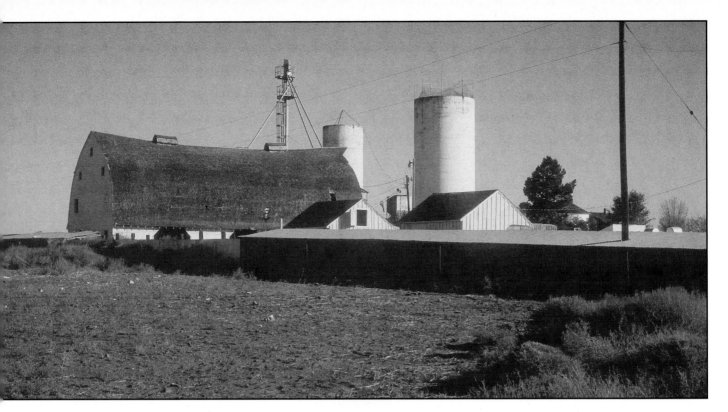

Contents

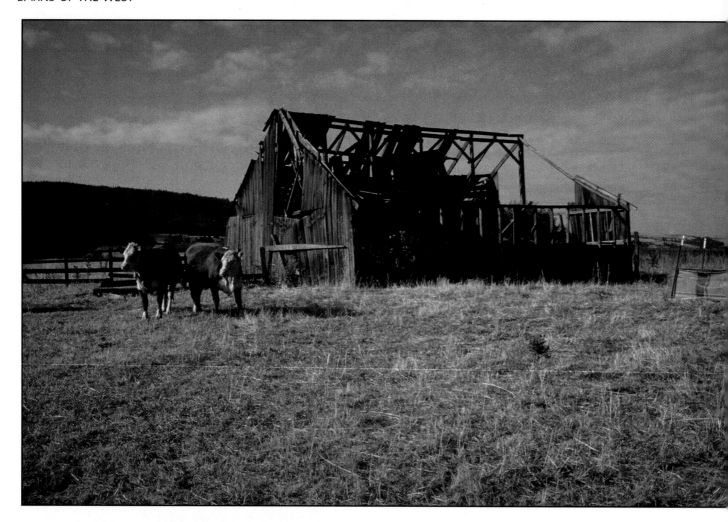

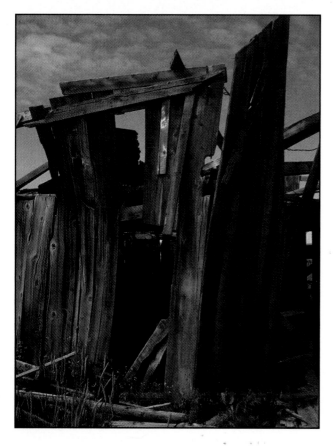

Above: Horses and beef cattle no longer find shelter in the ruins of this gable-roofed, braced-frame barn on Camas prairie, near Grangeville, Idaho.

Left: Hill Beachey, famous stage coach king and hotel keeper of the 1860s, built a stage barn at Inskip Station in Malheur County, Oregon, of which only this ruin remains.

Right: Although some would label this barn shape "Western," it will be seen in the pages that follow that it is by no means the commonest form found in the West. It is on a cattle ranch on the Malheur River, eastern Oregon.

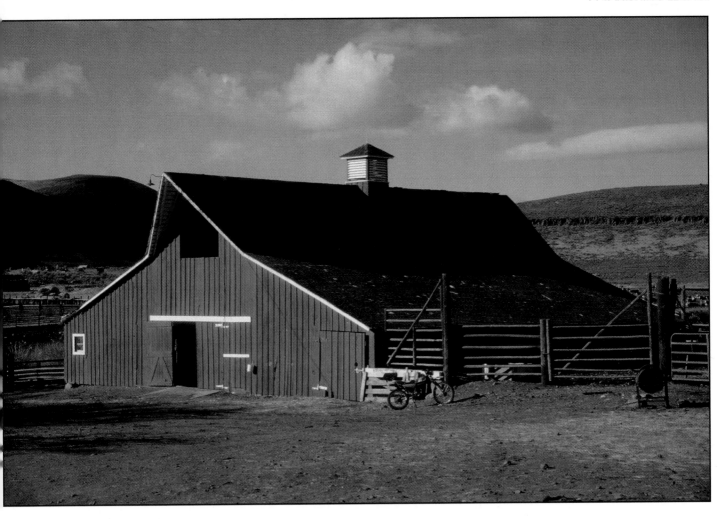

Introduction

Barns are among the most picturesque and evocative elements in the Western landscape. They are relics of a farm and ranch technology that has changed drastically in this century, and is still changing. Before World War I most agricultural work was performed by the muscle power of humans and animals. Steam traction engines had replaced horses in some farm operations early in the century, but it was still largely a horse-powered rural economy. The staple winter food of horses and mules, the principal draft animals, was hay. The technology was to cut wild or seeded hay with horse-drawn mowers, collect it into windrows with a horse-drawn rake, and haul it to the barn in a horse-drawn wagon. If a hay fork and trolley were used to lift the load off the wagon and move it into the barn, horses supplied the power

for that as well. Men supplied the muscle power to make windrows into haycocks of a size that could be hoisted overhead onto the wagon with pitchforks. In the West, haycocks (rounded mounds of hay) were usually called shocks — a term reserved for upright stacks of bundled grain and cornstalks in eastern states.

Most barns in the West were designed with a loft two or three stories high for storing long hay. The widespread changeover to baled hay made most of these obsolete, because a building well designed for handling and storing long hay was not efficient for baled hay. New kinds of storage structures were developed, usually little more than a simple gabled roof on a braced frame of poles or timbers, without benefit of siding. Unlike the well-built barns used for sheltering long hay and animals, these

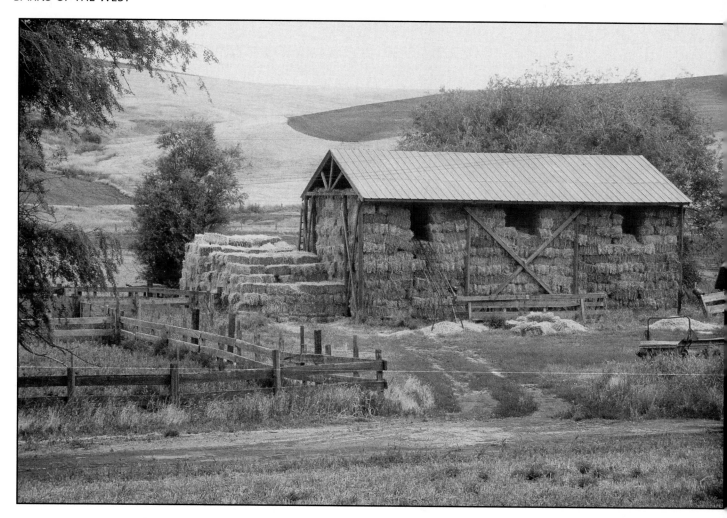

Hay barns like this, designed for storing baled hay, have replaced the snug long hay barns of the days when animals and their feed were housed in the same building. It is near St. John, Whitman County, Washington.

simple structures did not need a floor, and upright posts were often set in the ground like utility poles. Gasoline powered machines that could gather and move large numbers of bales at one time determined the dimensions of the new structures. When an old long hay barn was adapted for storing bales, a common expediency was simply to chain-saw a big enough opening around the front door to permit the machine to enter — a practice that threatened the structural integrity of the building.

Barns have historic significance because they are physical reminders of a way of life now largely gone for most Americans. The family farm of a century ago needed a barn that could provide feed and shelter for horses and cows, and often a place for chickens, hogs and sheep. As recently as 1908, stock plans for a family barn provided space for five horses, 10 cows, 50 chickens, and two breeding sows. In addition, it was

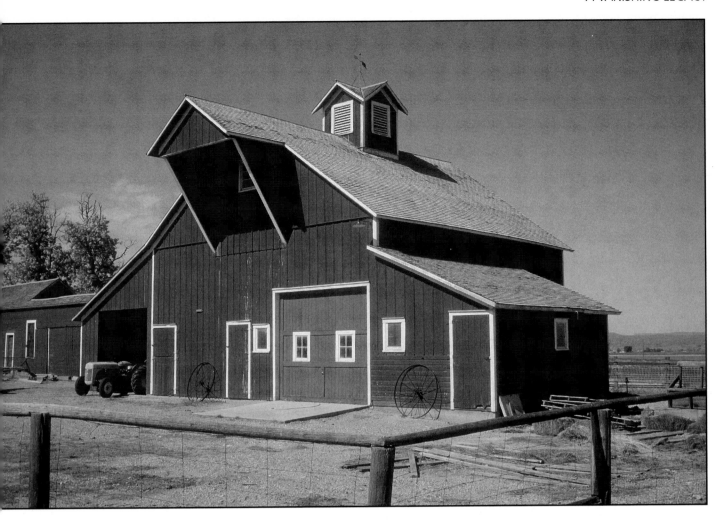

noted that "a box stall is almost an absolute
necessity some time during the year, either
for sick animals or because some special
attention is required."

When 80% of Americans lived on farms,
such an all-purpose barn was the rule. Now
that 80% of us live in urban areas, farming
has become "agribusiness" and most small
farms have been incorporated into large
ones. Houses on these former family farms
are often vacant or occupied by seasonal
laborers, and the old barns and out-
buildings are either abandoned or used for
storing machines. Ten or more family farms
that were once highly diversified may now
be part of one large specialized one, growing
a single crop and needing no animals at all.

Urban sprawl has also covered tens of
thousands of acres of once productive farm
land throughout the West. With rare
exceptions, there are no longer any barns left
standing within municipal boundaries.

*Reclamation pioneer J.H. Lowell built
this small family barn near Roswell,
Canyon County, Idaho. A recently
installed automatic overhead door
makes it useful as a garage for the
present owner.*

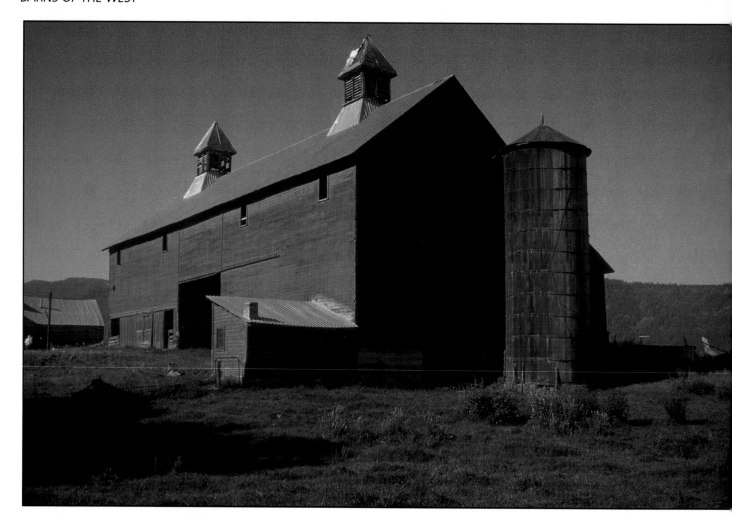

Those that remain have found adaptive reuse for businesses of a wide variety catering to home owners in new neighborhoods, such as farm stores, nurseries, hardware stores, and restaurants.

Obsolete and unused barns are torn down, or eventually collapse and rot away. Once the roof fails, the rest of the structure soon follows. In some parts of the West the weight of heavy winter snows completes the process of decay and collapse; in others it is high wind that rips away shingles, shakes, or metal roofing material. Another cause of the rapid disappearance of barns from the western states in recent years has been a fad for weathered wood in interior decorating, in boutiques, restaurants and private homes. Dozens of western barns have been sold or given away by farmers no longer needing the derelict building on the property, and glad to have it removed. One company that advertised regularly in California

newspapers sold "Barn Boards of Idaho" with considerable success. Farmers and ranchers can hardly be blamed for deciding not to re-roof a structure that no longer has economic value to them, especially since the expense of roofing a large barn is great. For some families, happily, the barn represents a meaningful link with the past, worth preserving and maintaining even if its traditional function no longer exists.

In 1987 The National Trust for Historic Preservation developed a program to call public attention to the significance of our disappearing barns, and to encourage owners to find adaptive re-uses for them. Called "Barn Again," the program has produced a television documentary and offered seminars nationwide in an effort to slow the loss of an important part of our heritage. Quite aside from their aesthetic or historic significance, which has wide appeal to most Americans, barns offer large

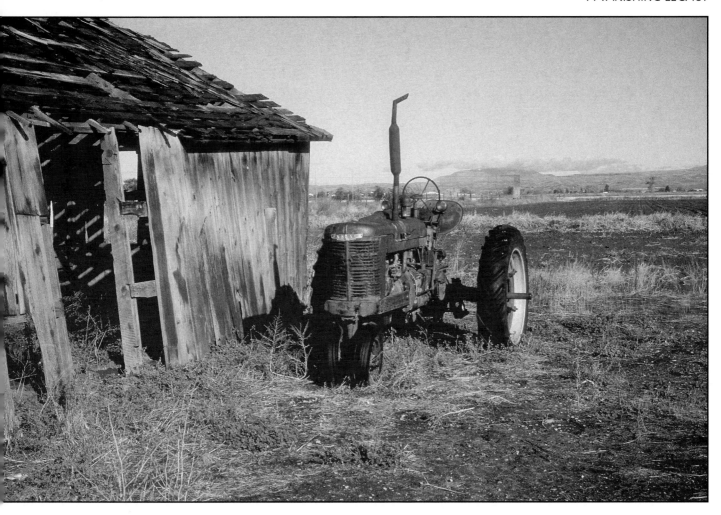

amounts of usable space for manufacturing, retail, and other commercial activities.

Because some of us, and most of our forbears, grew up on family farms, the old barn in the landscape evokes nostalgia and affection. We might never want to return to the hard work and precarious existence that was the lot of most small farmers, beset by drought, flood, hailstorms and insects, falling prices and national depressions, but we view this past way of life with fondness and sympathy. This book is for barn-lovers everywhere, but especially for people in the West for whom these pictures and words may evoke fond memories.

ARTHUR A. HART

Upper left: "Any color, as long as it's red" has long been the dominant taste among American farmers. The Haun barn near Lostine, Oregon, has a double crib plan. The left crib was built first, the other and the silo were added later. A modern aluminum roof has suffered wind damage.

Above: The gasoline powered tractor had replaced teams of horses on most western farms by 1940. It made the long hay barn obsolete.

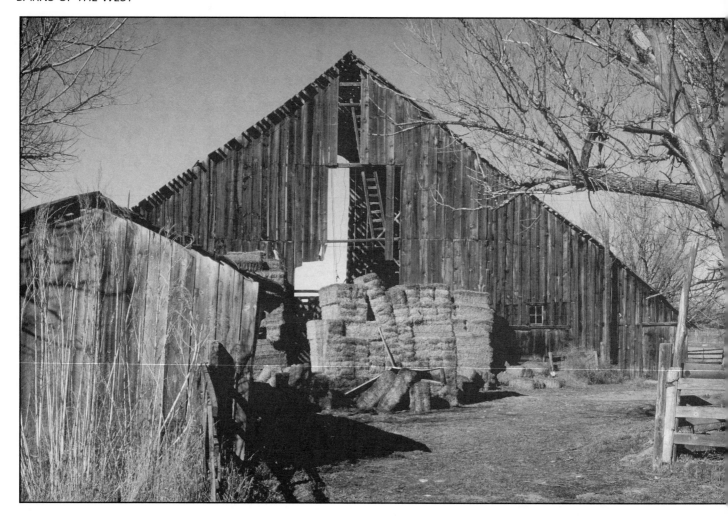

Above: Baled hay didn't fit easily into a traditional long hay barn. Boards were ripped or sawn off to get the bales in.

Next page: The Harry Grose barn in Beaverhead County, Montana, has transept gables, and steep roofs that shed heavy winter snows. Its unlouvered octagonal turret is a decorative addition.

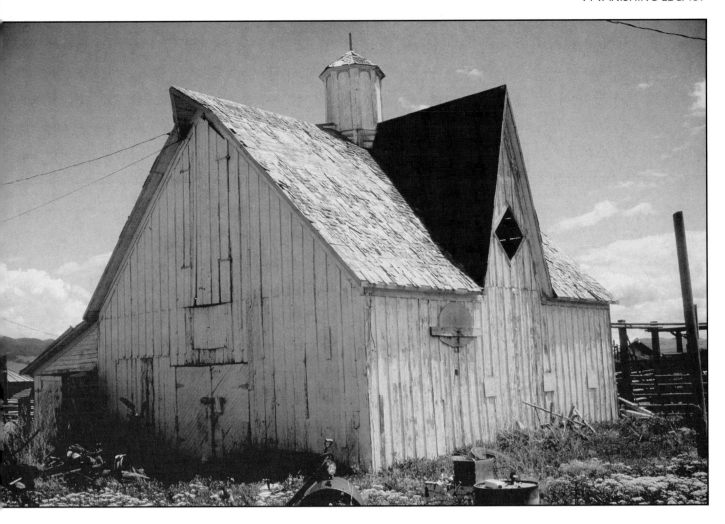

Barn Structure: Braced Frame

Even at a distance you can tell much about a barn's construction. If the exterior siding boards are nailed on vertically there is a braced frame of squared timbers or logs underneath. The horizontal members of this frame provide the nailing surface for vertical boards. If the exterior siding is horizontal, there is probably a balloon frame underneath with vertical studs.

Braced frame construction has been employed for more than 2,000 years. Stout corner posts are locked at top and bottom to horizontal beams with mortise and tenon joints. Mortises are slots, tenons are tongues of wood that fit into them. The joint is completed by boring a hole through both members and driving in a tapered wooden peg called a trunnel (tree nail). Diagonal braces, similarly mortised, complete the frame and give it great rigidity.

Vertical siding could be spaced to allow expansion and contraction and circulation of air. Narrow boards called battens were often nailed over the cracks to ensure a snugger interior for the protection of animals and grain in an all-purpose family barn. A family's pride in its barn was often shown by painting the battens a contrasting color — usually white on red. This "candy-stripe" effect, enhanced by painting door and window frames white as well, resulted in very handsome structures, leaving no doubt that esthetic considerations were important to farmers and ranchers. Milled battens in a variety of shapes added extra elegance (and expense) to a family barn or stable. In remote mountain areas of the West barns were more primitive and battens were often omitted.

11

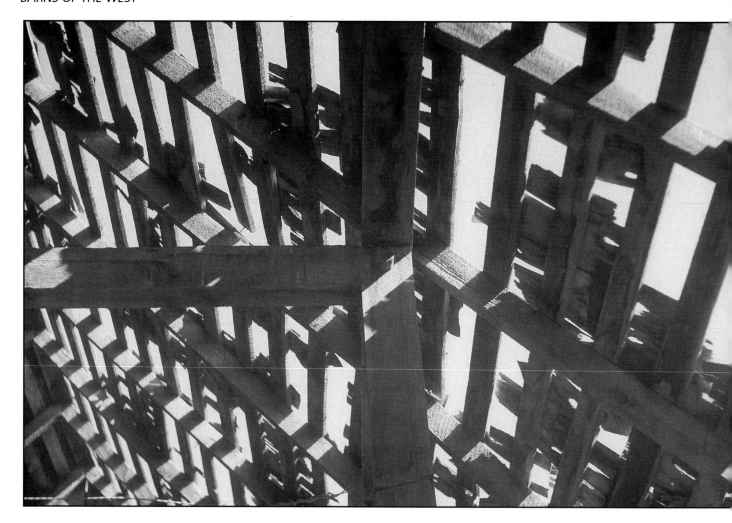

It is often fondly pointed out that this or that braced frame barn was put together "without a single nail." This is probably true of the frame, but siding and roofing were nailed on. After all, cheap manufactured iron nails have been available in the West since the 1850s. A farmer might hand forge some of the hardware for his barn, such as hinges, hasps, staples and door latches, but to hand-make several thousand nails was never practical.

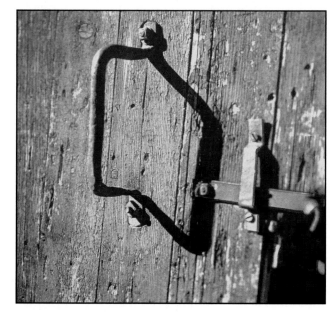

Top: This classic braced frame barn holds together long after its roof has rotted away.

Above: Farmers hand forged some barn hardware, like this door handle, but did not make the thousands of nails needed to put on siding.

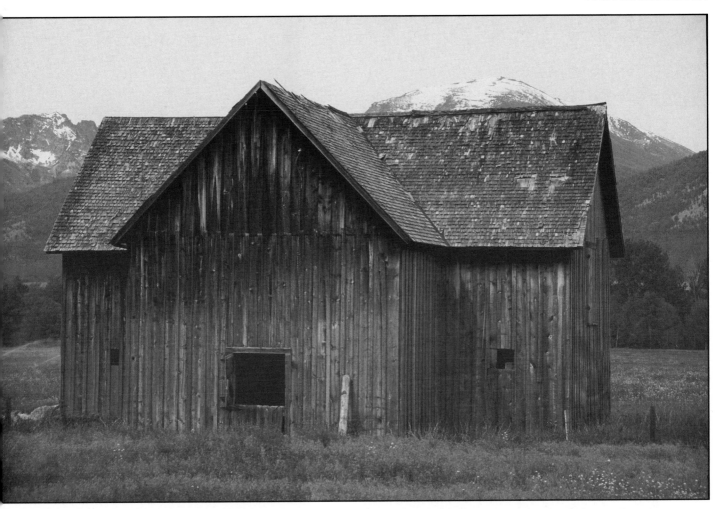

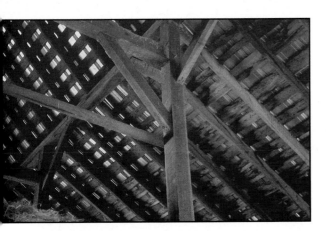

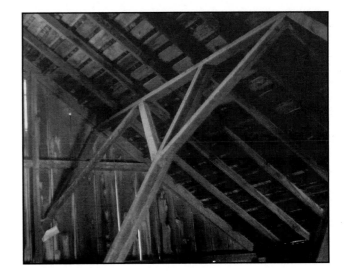

Top: This Bitterroot Valley barn in Western Montana has a cross-shaped floor plan like some early churches. The vertical siding tells us that there is a braced frame underneath.

Above and right: Typical examples of braced framing.

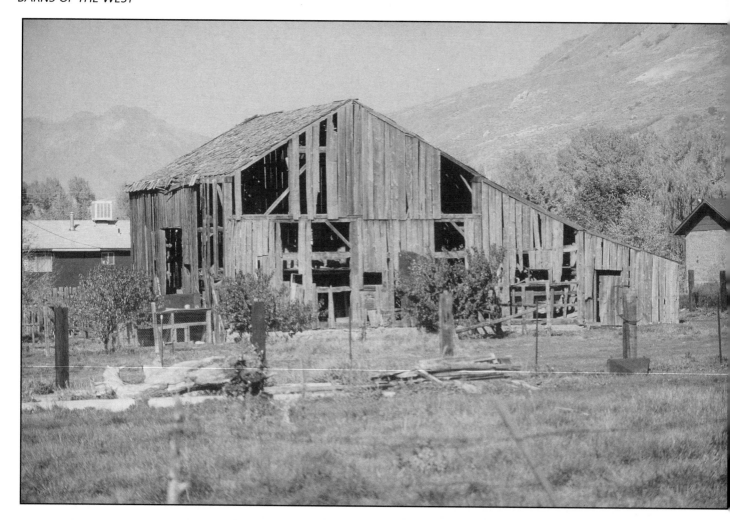

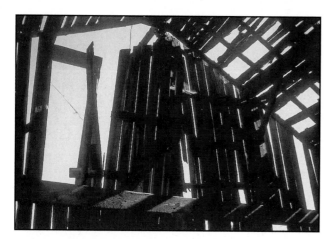

Top: The 1853 George M. Mason barn in Willard, Utah, is one of the oldest in the West. The lean-to at right in this view gives it a salt-box shape. Willard is a Mormon town at the foot of the Wasatch Mountains, settled soon after Brigham Young and his people arrived in Great Salt Lake valley.

Left: Hay doors on the Mason barn.

Above: Primitive board and batten siding.

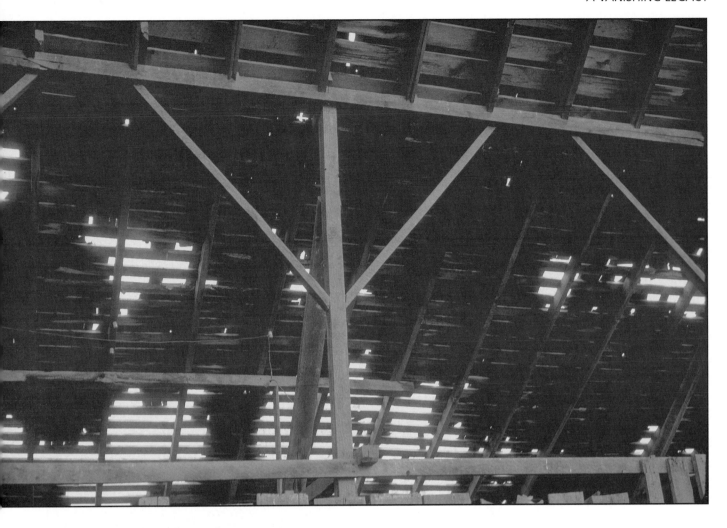

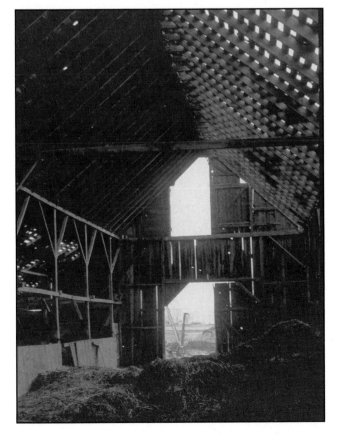

Later braced frames were built with lighter lumber. Steel bolts rather than wood pegs held them together.

At left is an interior view of the same well made but neglected barn.

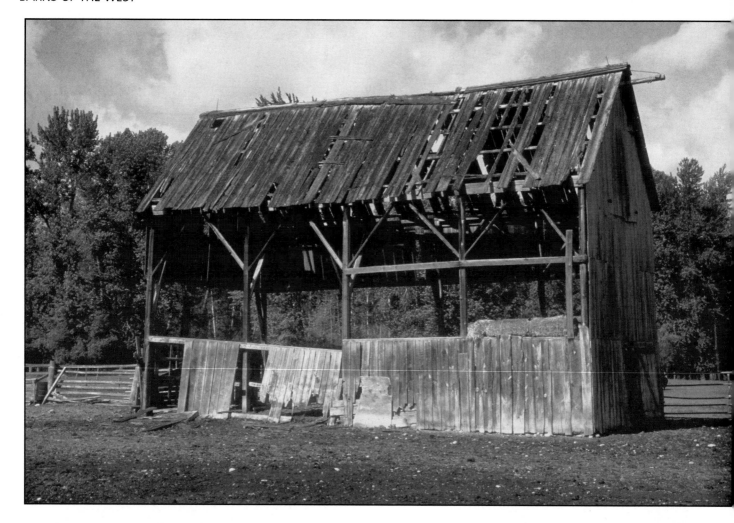

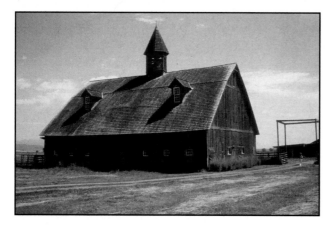

Top: Near Conner, Ravalli County, Montana.

Above: Baker County, Oregon.

Right: Ada County, Idaho.

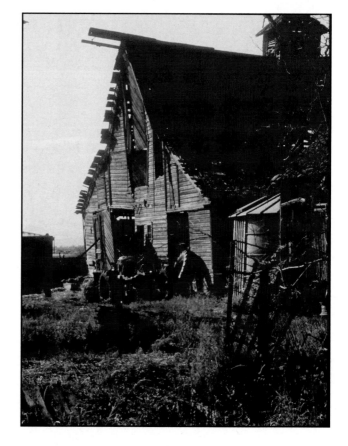

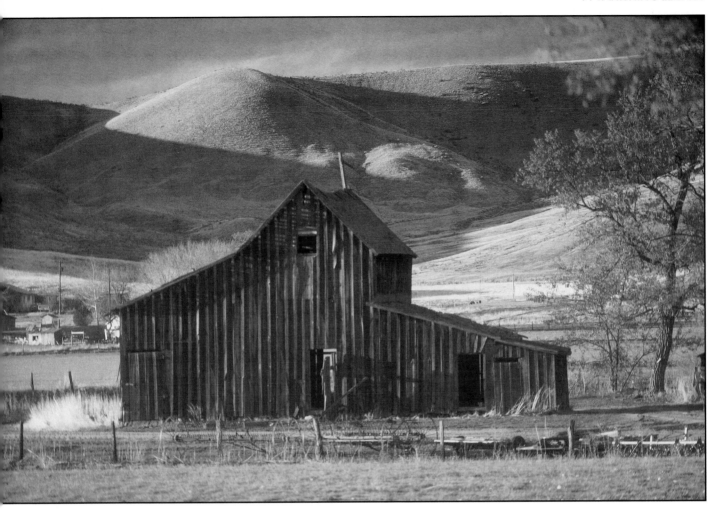

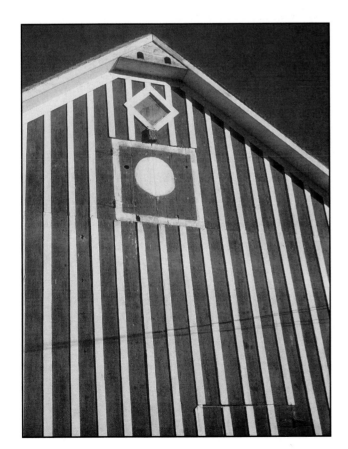

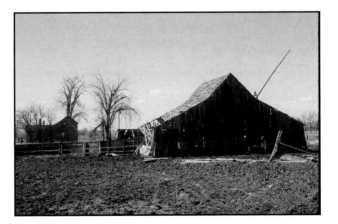

Top: This pioneer gable barn on Dry Creek, Ada County, Idaho, has since collapsed.

Above: An abandoned farmstead in Gem County, Idaho.

Left: Classic "candy stripe" board and batten.

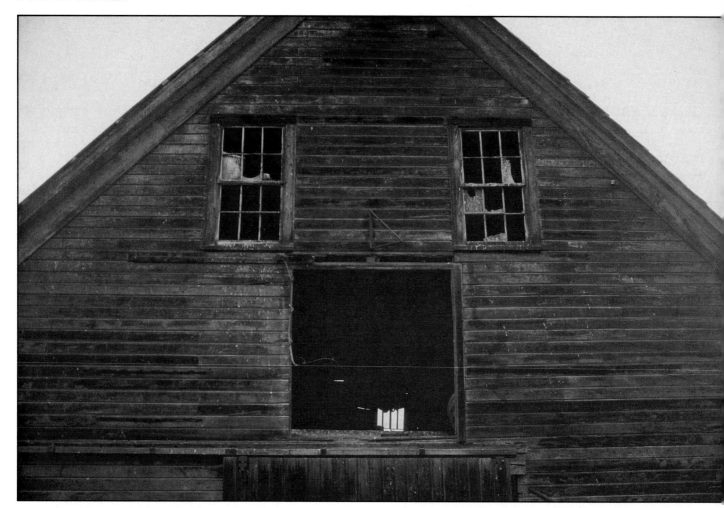

Top: This Halloween faced barn in western Washington seems to scream in horror.

Above: Wallowa County, Oregon.

Right: Champion cowboy Dean Oliver owned this 1930 balloon frame barn near Old Ustick, Idaho.

Top right: Upper Snake River barn.

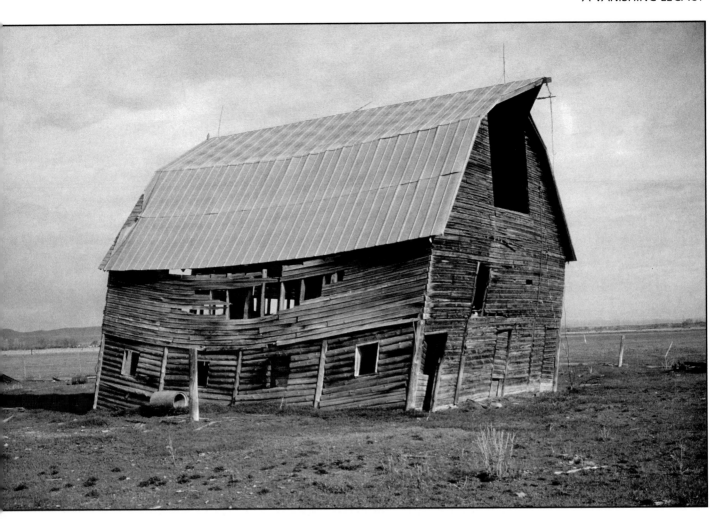

Balloon Framing

Often called stud construction, balloon framing was the system most often used in barn building after about 1890. It had been used in houses and other buildings for 50 years by then, and is still the standard method of residential construction today.

Vertical studs, usually 2x4 or 2x6 inches in dimension, spaced 16 or 24 inches apart, are nailed to a wooden sill. A horizontal plate ties the top of the wall together and supports rafters or second floor joists. The studs are doubled up for extra strength where needed. Horizontal siding, which may be clapboard, shiplap, or plain boards edge to edge, is nailed to the vertical studs. In houses, sheathing of some kind is nailed on before the siding, but in barns is usually omitted.

A common failing of inadequately braced balloon frames is that they succumb to the constant pressure of prevailing winds and gradually begin to lean away from them. What begins as a rectangular facade becomes a parallelogram. Indeed, one barn near Filer, Idaho, has the reputation of leaning eastward when the west wind blows, and westward when the wind is out of the east. This deficiency in balloon framing, if no sheathing is used, can be mitigated by the use of long lateral braces nailed diagonally across a stud wall, tying corner to corner.

When balloon framing was employed in building granaries, as it was throughout the West, horizontal boards nailed edge to edge were attached to the inside of the frame where the weight of the grain could not force the nails out of the studs. Another obvious advantage of this was a smooth inside surface without the impediment of

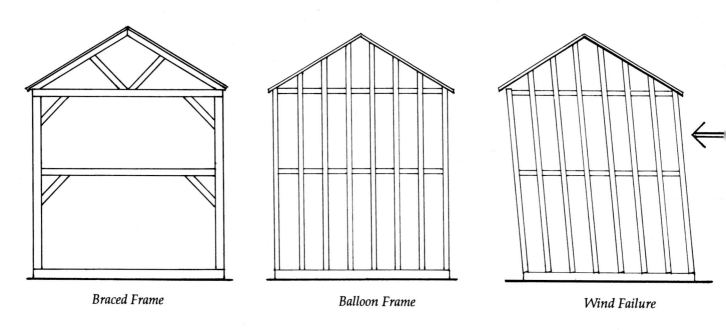

Braced Frame *Balloon Frame* *Wind Failure*

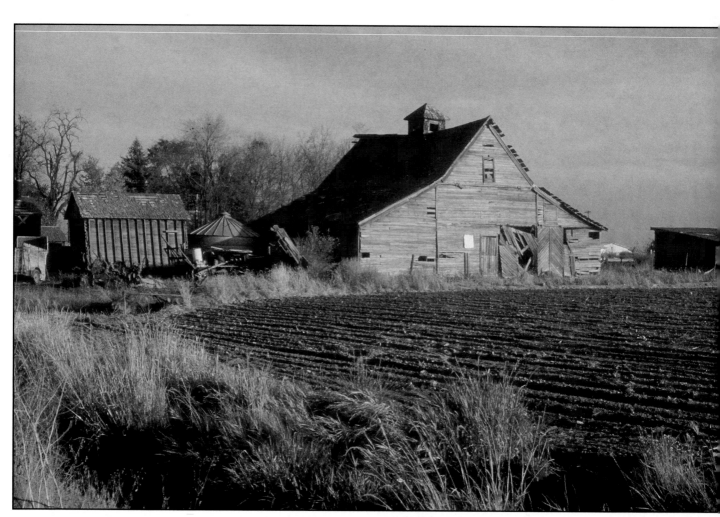

Note the balloon-framed granary at left above.

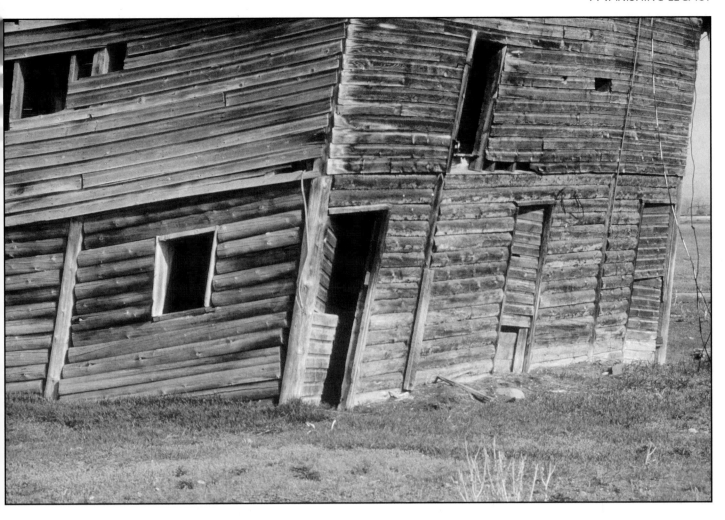

studs when grain was shoveled out. As logical and practical as this arrangement is, people have been known to ask "why was that building built inside out?"

Both braced frame and balloon construction lend themselves to fabrication of major elements on the ground before raising them into position. The traditional term "barn raising" derives from this practice. Many neighbors gathered together to raise what in timber construction are called "bents," with pike poles and ropes. Because of the enormous weight, 25 or more men were often needed to raise a single bent into position.

Men riding on the bent then locked it in place with previously cut mortises and tenons. By contrast, balloon framing is light enough that panels of stud wall can be raised into position by just a few men.

A classic example of balloon frame failure due to inadequate lateral bracing.

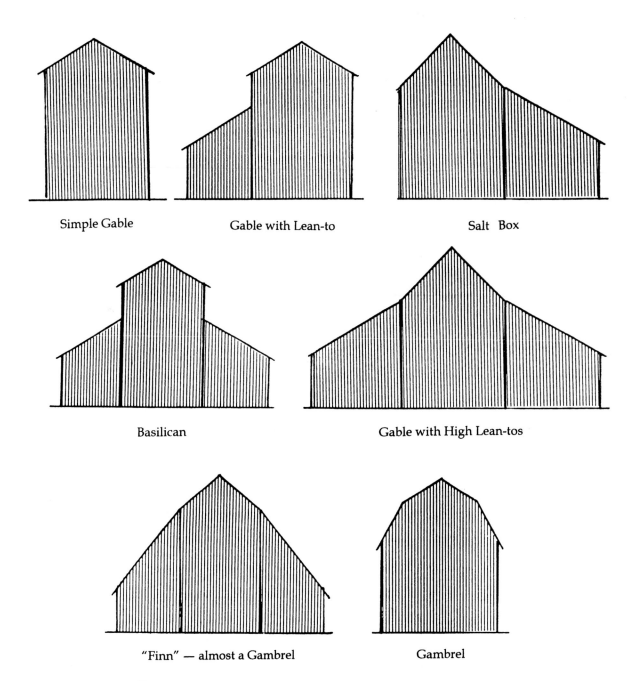

Simple Gable

Gable with Lean-to

Salt Box

Basilican

Gable with High Lean-tos

"Finn" — almost a Gambrel

Gambrel

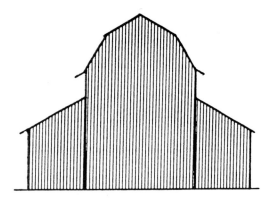

Gambrel Basilican

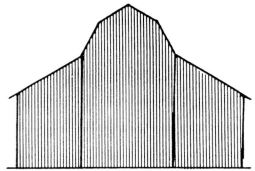

Gambrel with High Lean-tos

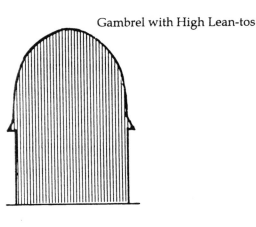

"Gothic" Round

Roof Styles

Barn shapes are largely determined by the style of roof chosen. Most early barns in the West had a simple gable roof, with lean-tos added in a variety of ways. The height of the lean-tos and the variable pitches of their roofs created forms familiar to western barn watchers.

The gambrel barn and its variations became the commonest western barn in the Twentieth Century, and is probably the most numerous style still standing. Its obvious advantage is the increased space in the haymow created by its bulging four-plane form.

Although proportions vary widely, those above are common barn shapes in the West.

23

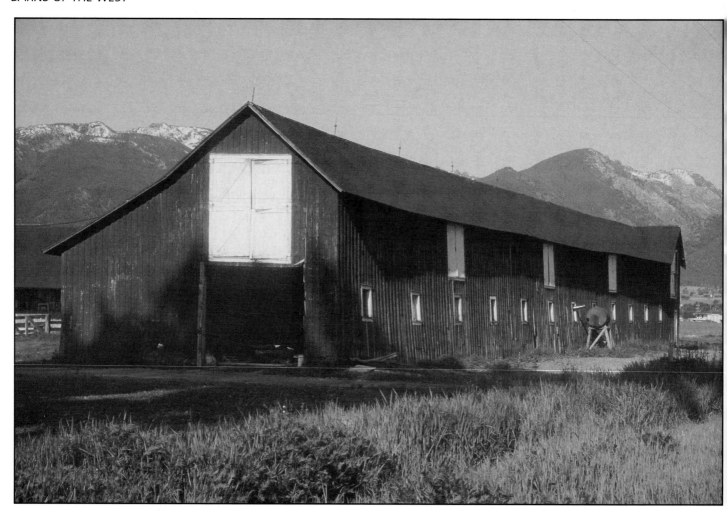

Montana's Bitterroot valley has been a horse breeding center for over a century. This big red saltbox barn is near Hamilton, Ravalli County.

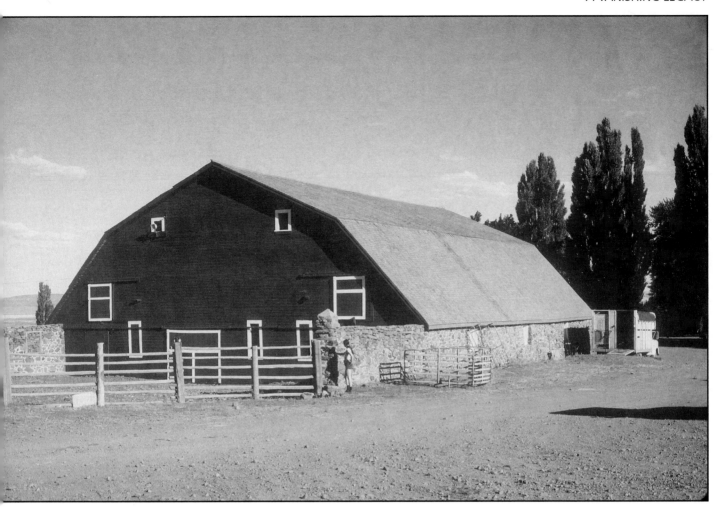

*Eastern Oregon's great Alvord ranch,
at the foot of Steens Mountain, has
barns, corrals and outbuildings made
of stone.*

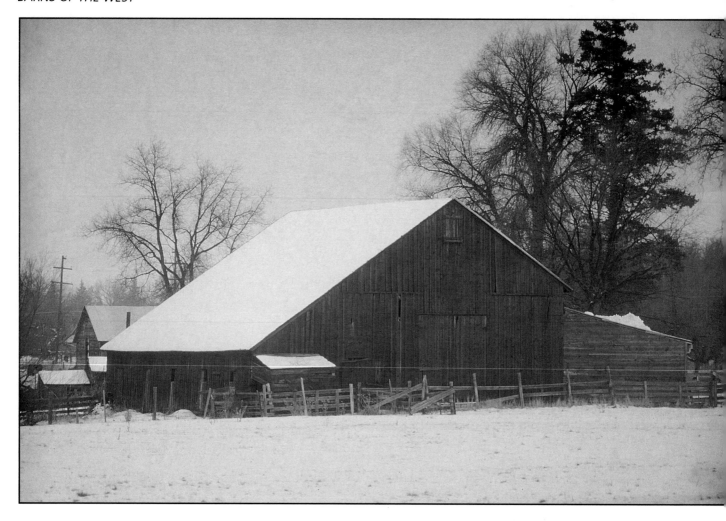

Union, Oregon, is an architectural treasure house. Its nearby ranches have superb barns in a variety of styles.

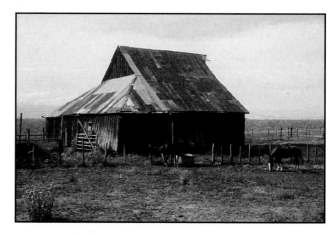

As galvanized sheet iron roofs rust away, rich patterns of color appear. This one is near Grangeville, Idaho County, Idaho.

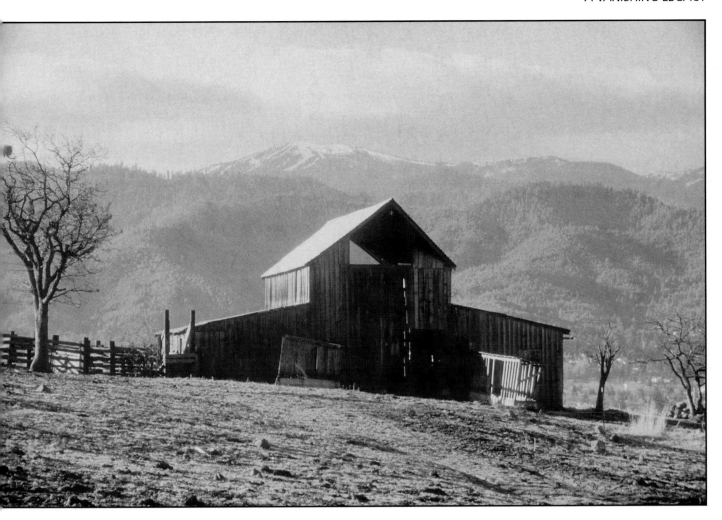

The Siskiyou Mountains form a pleasing background for a basilican barn east of Ashland, Jackson County, Oregon.

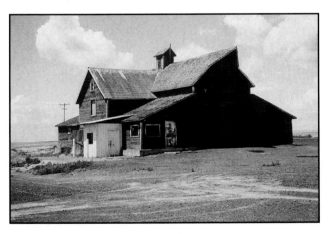

This big Adams County barn is a landmark in the wheat fields of eastern Washington. It can be seen for miles.

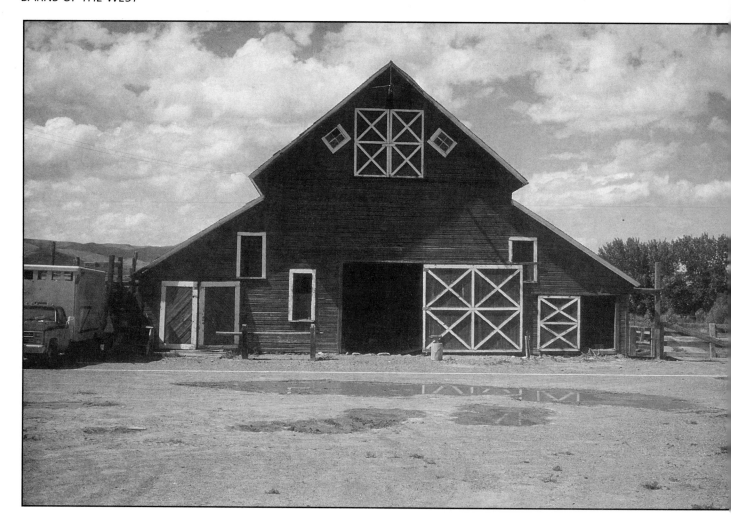

Robert Noble, an Idaho sheep king, built this horse barn some time before 1898. It is on Reynolds Creek, Owyhee County.

Dry farm wheat fields surround this abandoned barn near Rockland, Idaho.

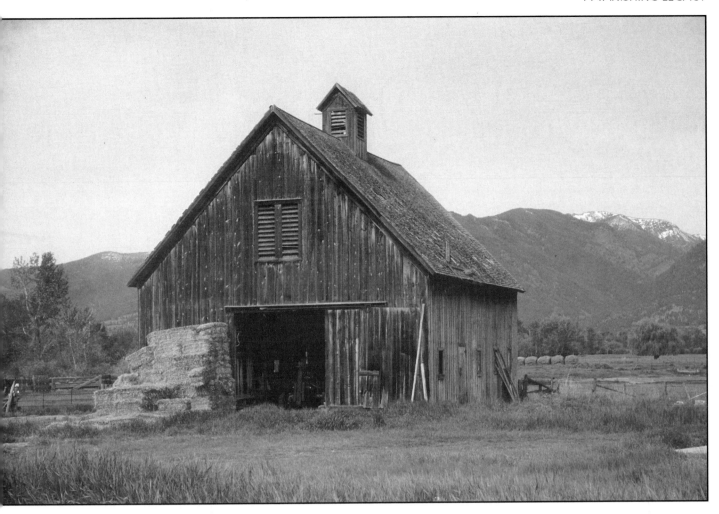

A barn built for long hay storage near Stevensville, Montana, now houses bales.

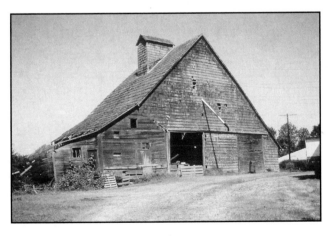

Lewis County, Washington, is dairying country. This barn was adapted for use as a granary. It is near Chehalis.

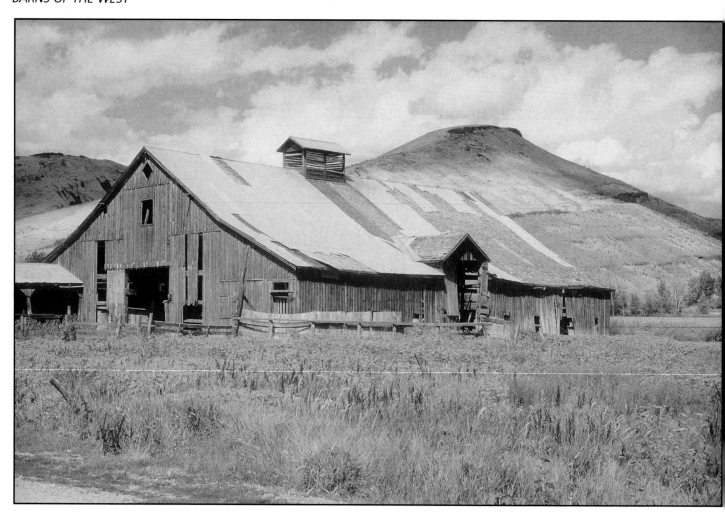

Once an important freight stop on the road from Umatilla, Oregon, to Idaho's Boise Basin, the Marsh and Ireton ranch's 1879 horse barn was demolished, along with the entire town of Montour, after disputes with the U.S. Bureau of Reclamation over Payette River flood control.

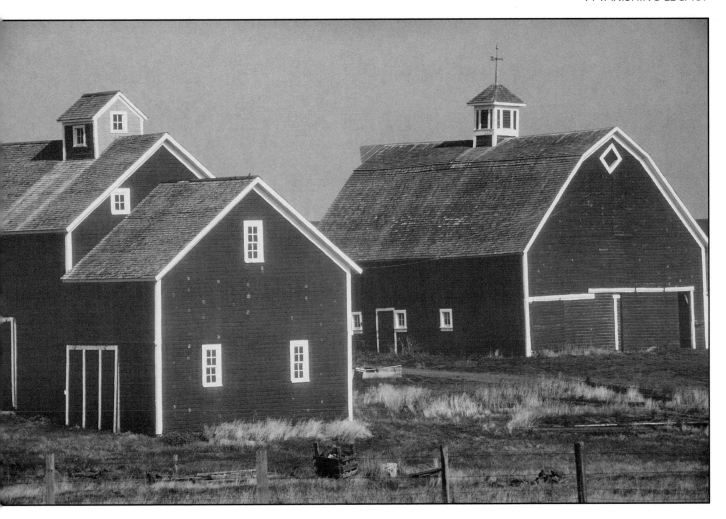

Camas Prairie, Idaho County, Idaho, is a rich grain producing area notable for barns in every style. These two exhibit three roof forms, and a paint job to be proud of.

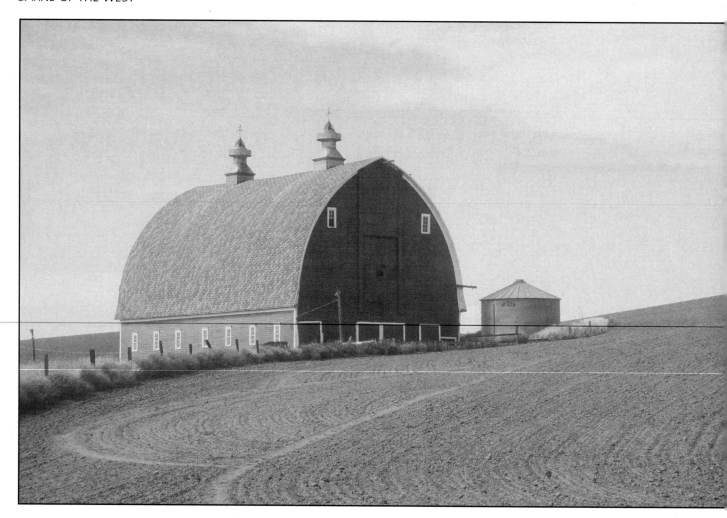

Locals call Palouse barns like these "round tops." Note the manufactured steel ventilators and storage bin.

The materials used to roof barns have varied greatly over time and from place to place. Early Utah barns were often roofed with sawn boards laid vertically from ridge pole to eaves. In western Oregon and Washington hand-split red cedar planks were used in the same way. Froe-split shakes of cedar or tamarack were used in some areas before sawn shingles were available. After the railroads came, corrugated galvanized sheet iron was used — a material that added to the life of many an old barn and added to its rich patina as it rusted in varying degrees. Since about 1950 corrugated aluminum has been used, and

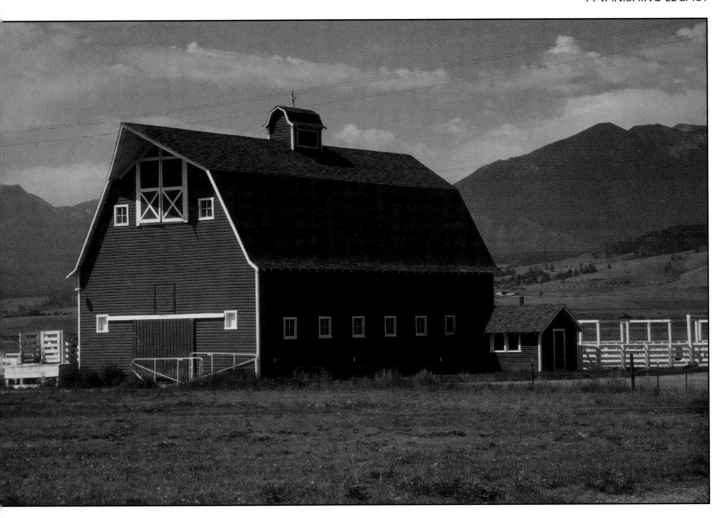

The Elkhorn Ridge of eastern Oregon's Blue Mountains forms a backdrop for this Baker County beauty. Would you say of its face that it has a wrinkled brow and a zippered mouth?

although it does not rust, it is highly susceptible to wind damage. Many early log barns in western Montana and Idaho had flattish roofs of lodgepole pine poles laid close together. A layer of hay or straw was topped with a heavy layer of earth. Although leaky in a spring thaw, or after a heavy rain, these earthern roofs had useful insulating properties in freezing weather, especially when topped with snow.

Barns in recent years have had cedar shingles replaced with less expensive asphalt ones. Whatever the material, maintaining a good roof is essential to the life of any wooden building.

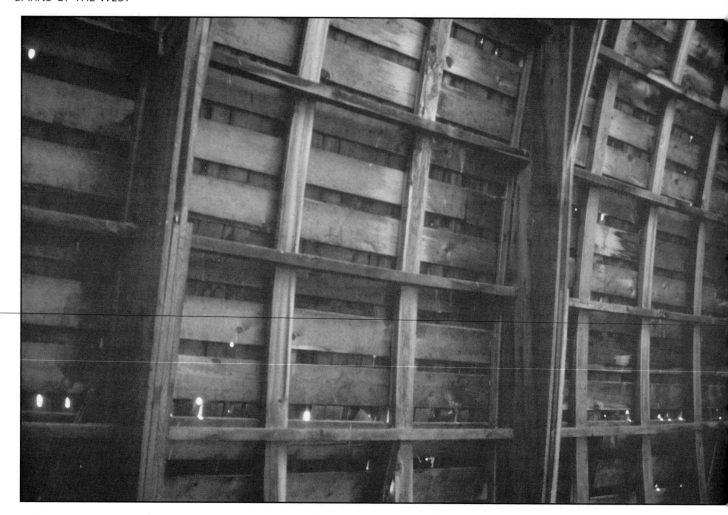

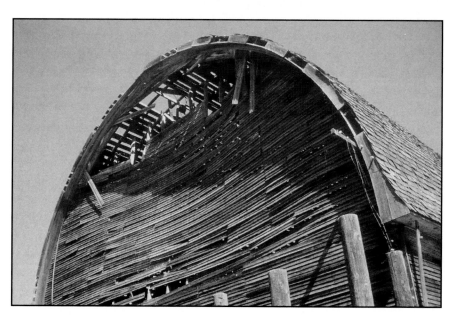

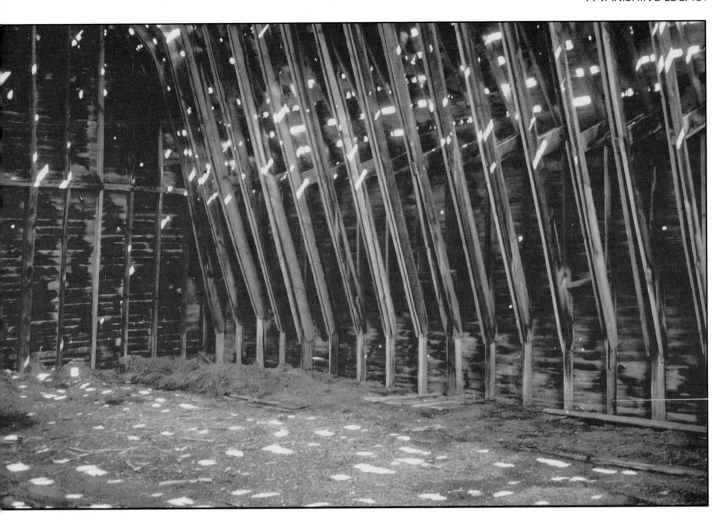

Upper left: Round-roofed framing looks like this from inside the hayloft. This barn was built in 1919.

At left: A neighboring round roof barn, also of 1919, is about to collapse because its roof was not maintained.

Above: Typical gambrel framing in a barn near Conner, Montana.

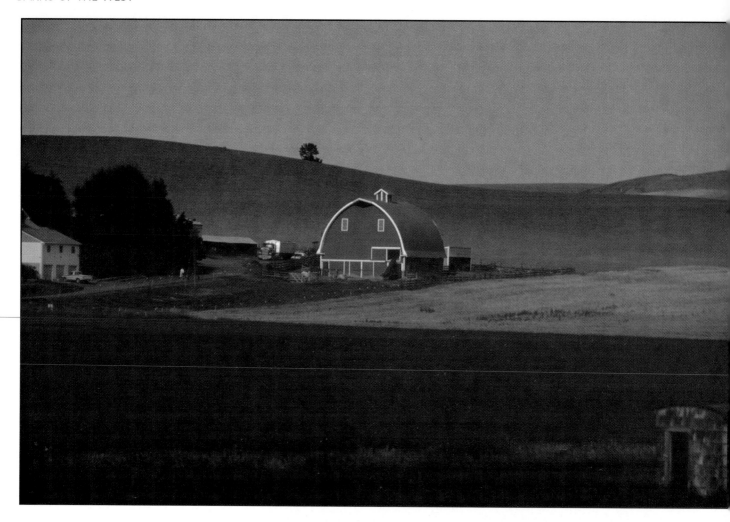

A Palouse roundtop in bright red stands out against rolling hills of young wheat.

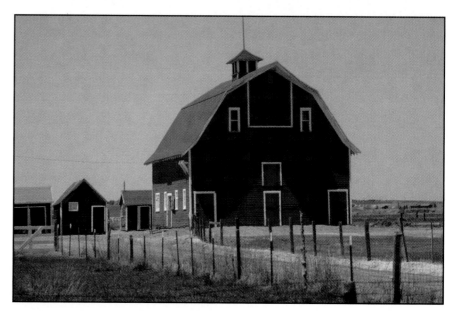

Twin Falls County, Idaho, has dozens of gambrel barns like this, built from similar plans.

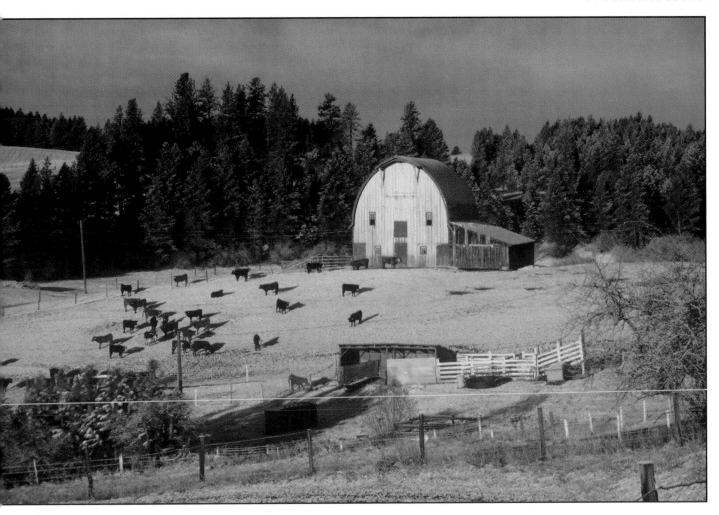

Idaho County, Idaho.

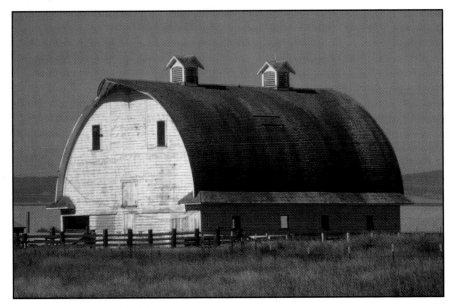

Asotin County, Washington.

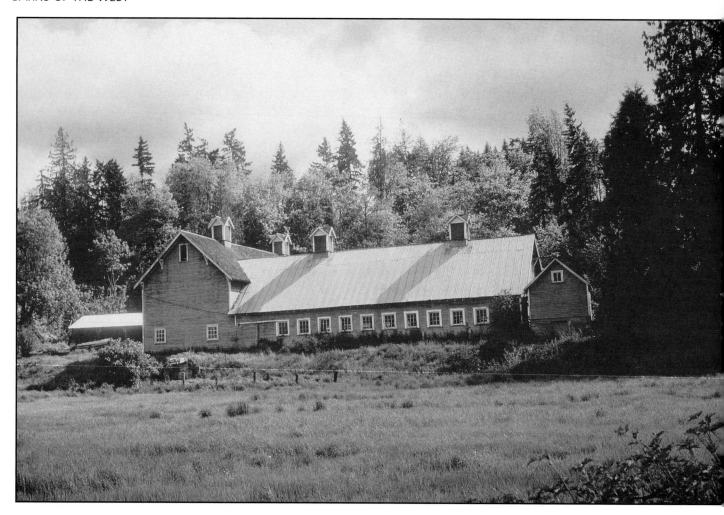

*These splendid well kept dairy barns
in Maple Valley, near Renton,
Washington, looked like this in
May, 1975.*

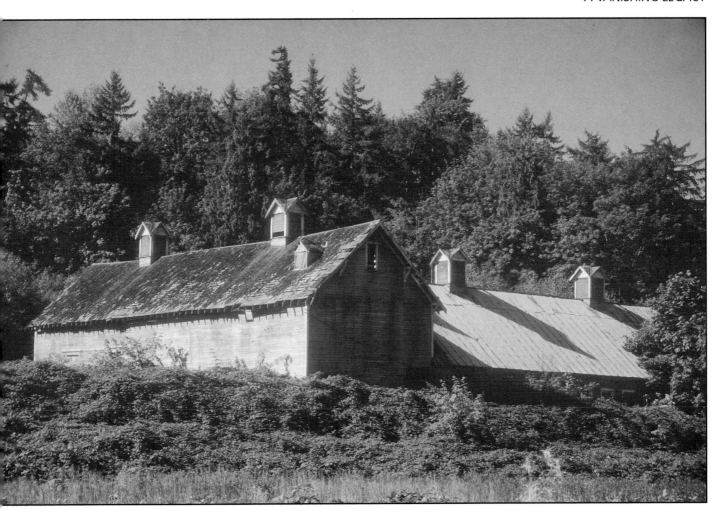

Now abandoned, the same structures looked like this in September, 1996. Their days are certainly numbered unless a viable adaptive reuse can be found.

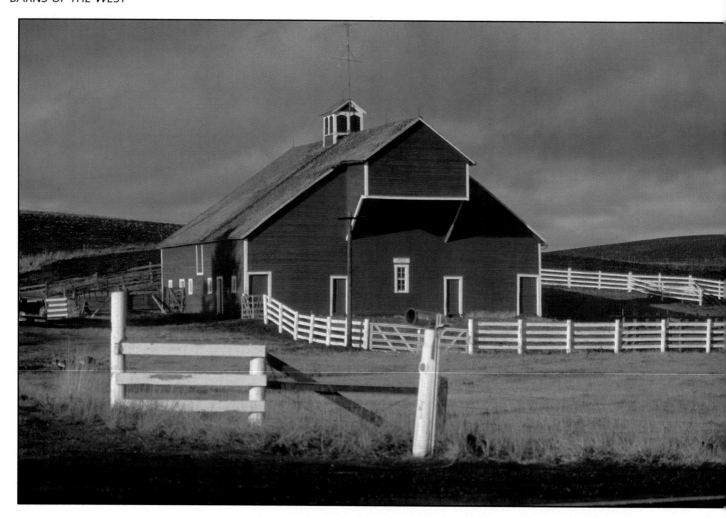

This handsome red Palouse barn on U.S. 95 is photographed often. Its enclosed hay hood and white fences and trim make it a standout.

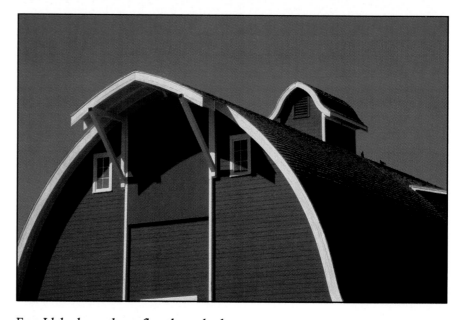

Few Idaho barns have flared gambrel eaves like those on this Nampa ventilation turret. They repeat the shape of the main structure. The hay door is the sliding type, under a braced hood.

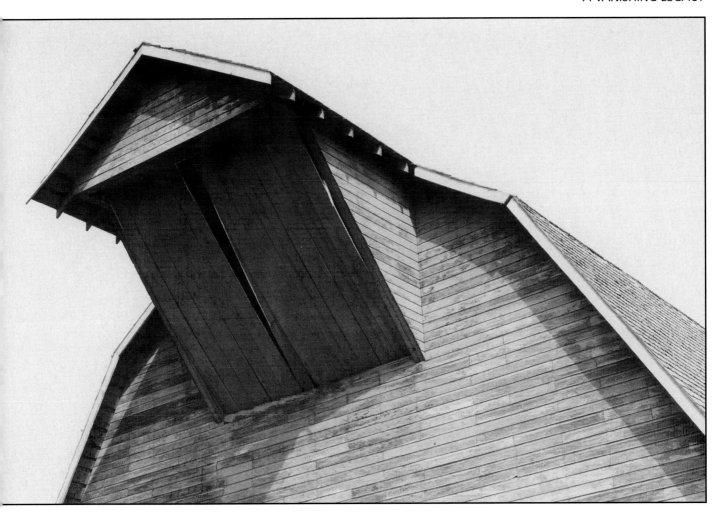

Hay Doors

The large loft door, into which hay was loaded from a wagon below, could be designed in several ways. Typically, a rail ran the length of the barn with a mechanical hay fork suspended from it on wheels. The fork, with long opposing tines, could grasp and lift a large chunk of hay from the wagon and carry it along the ceiling track to wherever it was decided to trip the load. A man with a pitchfork then distributed it to be sure the full capacity of the loft was realized. This dusty job may have given rise to the term "hay fever."

A hood, often a simple extension of the roof, sheltered the hay door. It could be square or triangular when seen in profile, or a large box-like structure with doors of its own at the bottom. If a simple hood, the opening into the mow had its own door, or doors. One kind was suspended on a rope

Many Grande Ronde Valley barns near LaGrande have hoods like this one at Island City, Union County.

41

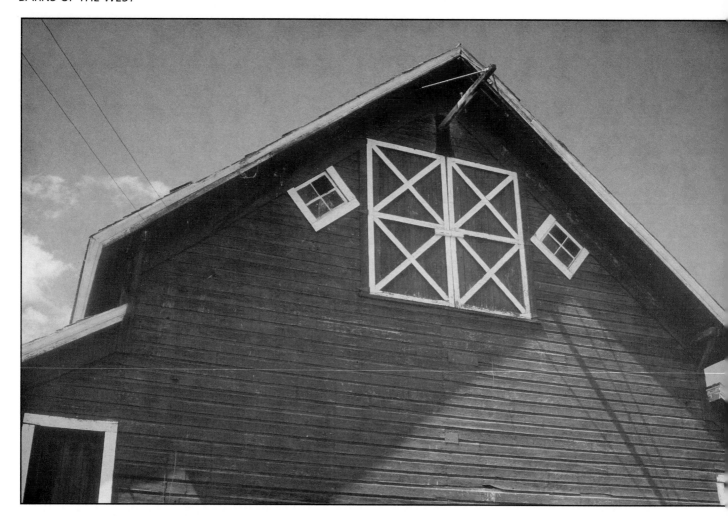

Bob Noble's Reynolds Creek barn (see page 28 also) has double hay doors. Their diagonal bracing is painted to present a pleasing decorative effect.

and pulley and rode up and down between vertical tracks. Others were hinged at the bottom and flopped open, and some were hinged at the sides of the opening, either in pairs or singly.

In some sections of the West, barns were often oriented with the hay door facing away from the prevailing wind. In others orientation was determined by convenience to the farmyard itself, or simply to have the gable end of the barn face the road. Since elaborate precautions in plans insured that the main door into the haymow could be snugly closed, the orientation away from prevailing winds may have become simply a local tradition rather than a practical necessity.

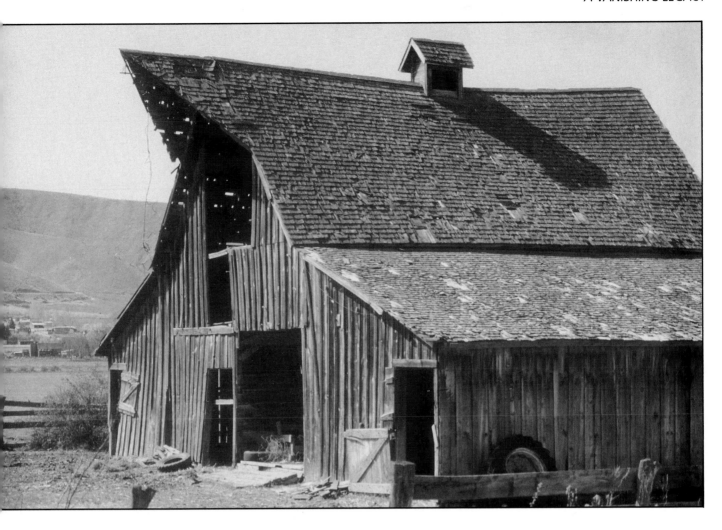

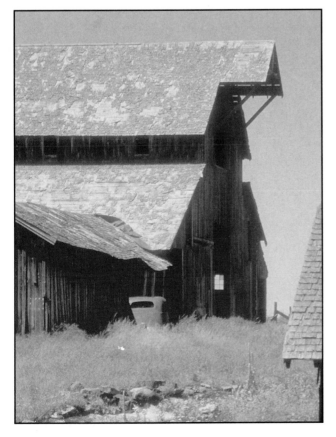

This triangular hood extension is typical of the way many hay doors were sheltered.

Left: Square roof extensions, like that on this big abandoned barn in Lincoln County, Idaho, are also common.

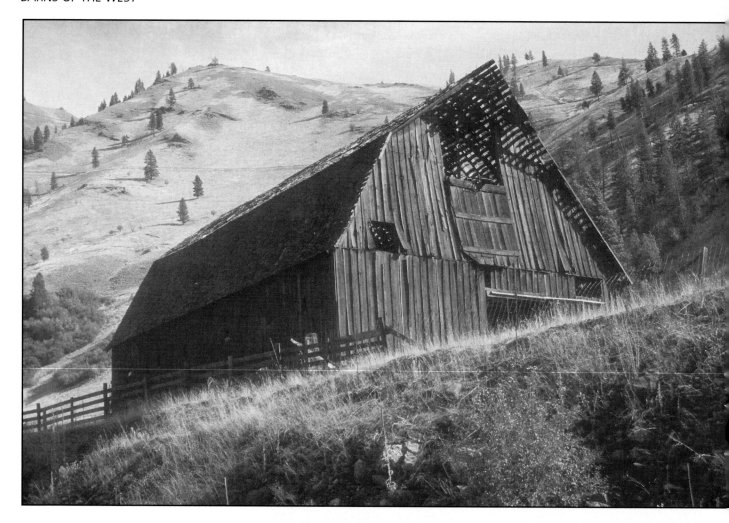

Bottom hinged hay doors flopped down. This old timer on Idaho's Little Salmon River collapsed in 1995.

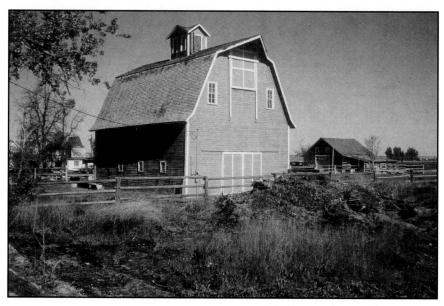

A well-kept gambrel barn with sliding hay door.

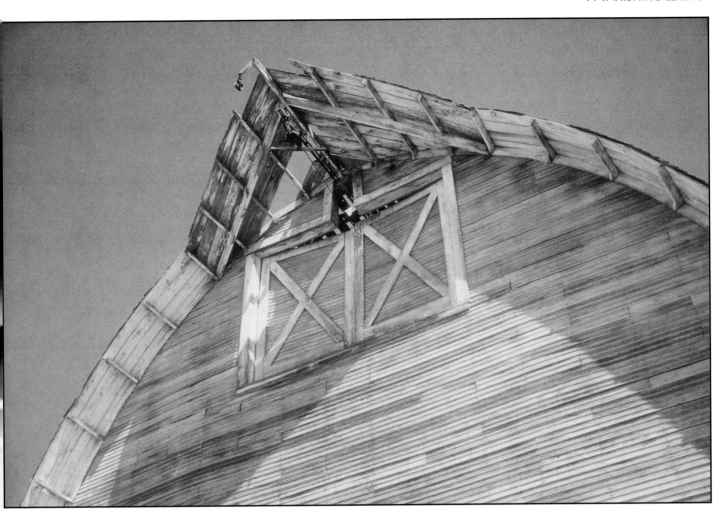

Double hay doors on a 1910 barn.

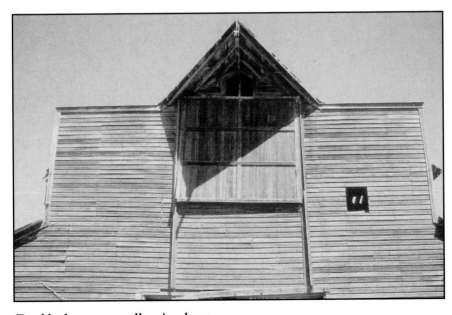

Double doors on a collapsing barn with a false front. The false front made a convenient sign board for businesses such as livery stables.

45

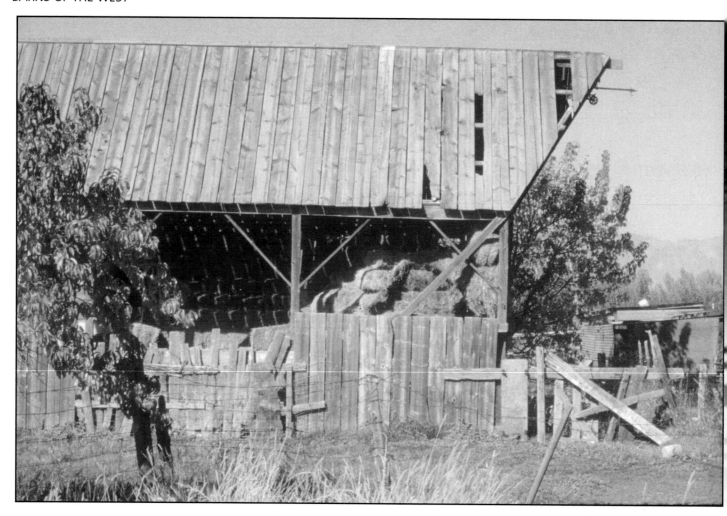

Utah barns often had board roofs and open hay doors.

These double doors were sheathed diagonally to keep them square.

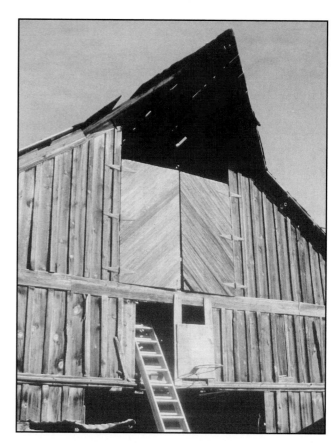

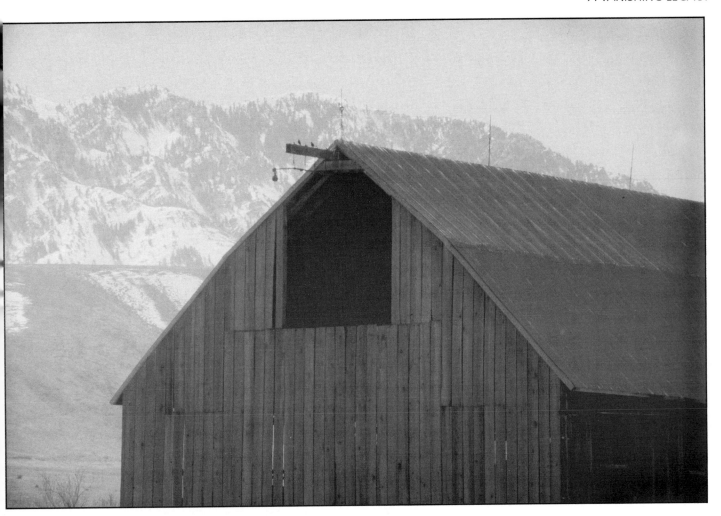

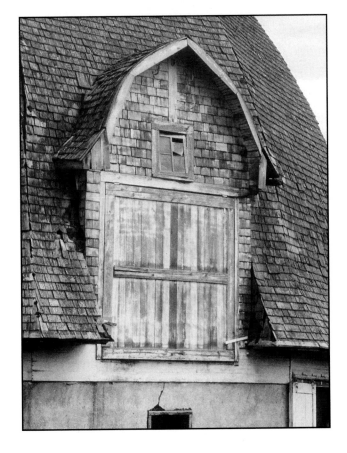

Many Mormon barns had no hay
hood. The hay carrier track is
exposed. This one is in Franklin,
Idaho's oldest permanent settlement,
founded in 1860.

Max Steinke's round barn in the
Palouse has double doors under a
gambrel dormer. (See also pp. 65
and 66.)

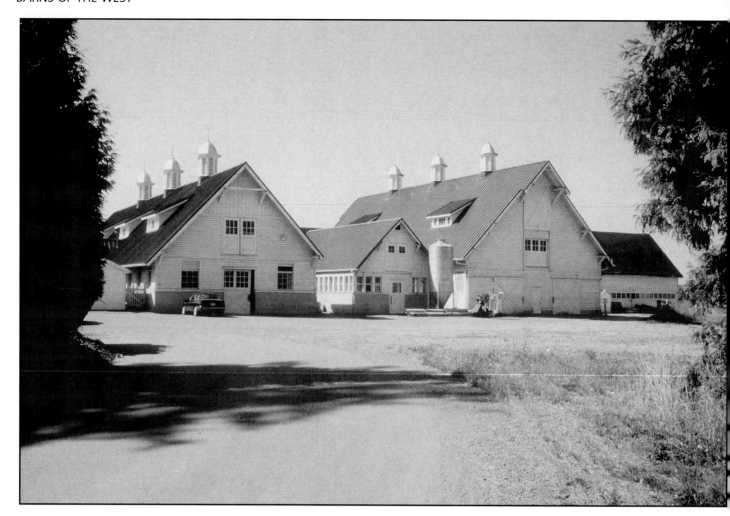

Washington State University's Puyallup Experimental Station has superb architect-designed barns with many cupolas.

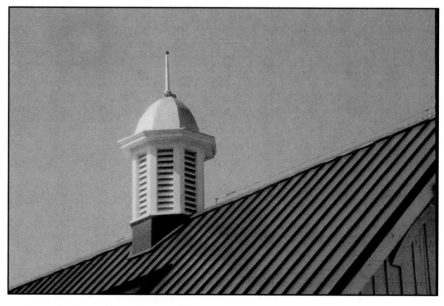

This detail shows that they are true cupolas with domed tops. Note the louvers for ventilation.

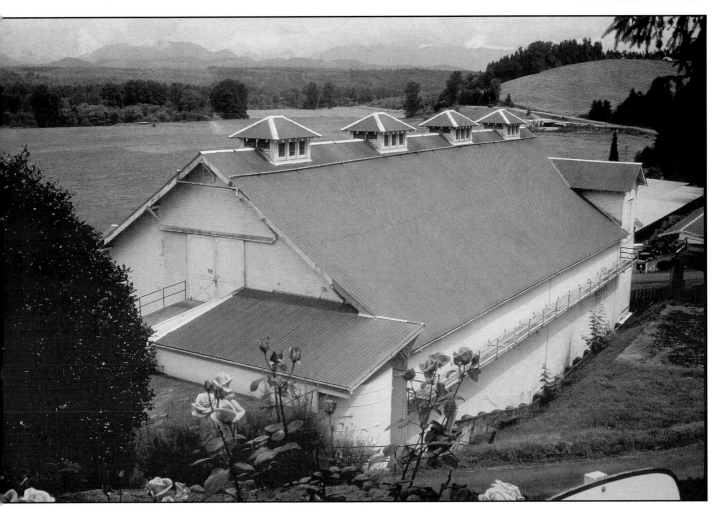

Roof Turrets

The structures atop barns, often called cupolas, were added primarily for ventilation of the hay loft, but could also furnish light and a distinctive decorative touch to the building. Wooden ventilating turrets usually had louvered openings on all four sides and a finial or weather vane on top. The roof of the turret might repeat the shape of the barn itself (gable on a gable, gambrel on a gambrel), or be totally different. Since ventilating turrets are often square, pyramidal roofs were common. Manufactured turrets of galvanized sheet iron, complete with rotating wind-driven fan blades, became available in the 20th Century. They were usually cylindrical in shape on a rectangular base to fit the roof.

Weather vanes could be ordered from a manufacturer, even in the mid 19th Century, in designs that suggested the specialty of the farm or ranch, such as horses, dairy cows, or bulls, but many were entirely individual, hand-made for a particular owner. These one-of-a-kind vanes are highly prized by collectors, and major museums of American folk art display them.

Also architect designed and well ventilated are the barns of the Carnation Research Farm and Gardens near Carnation, King County, Washington.

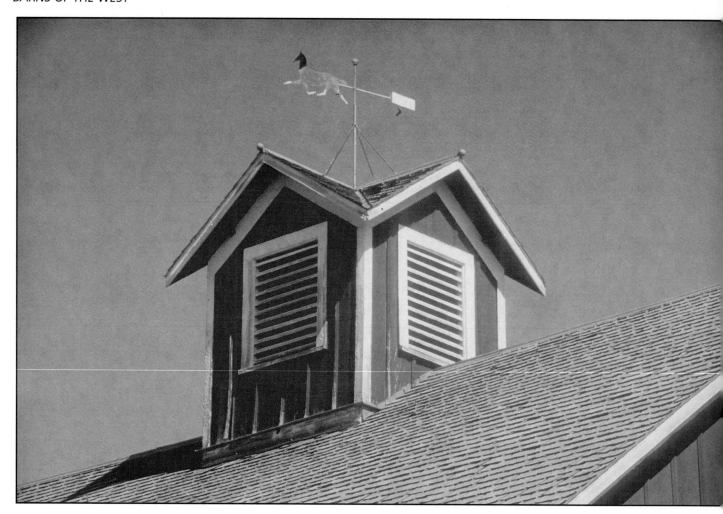

J.H. Lowell's barn near Roswell, Canyon County, Idaho, has a home made running horse weather vane — an all-time favorite choice to top American barns.

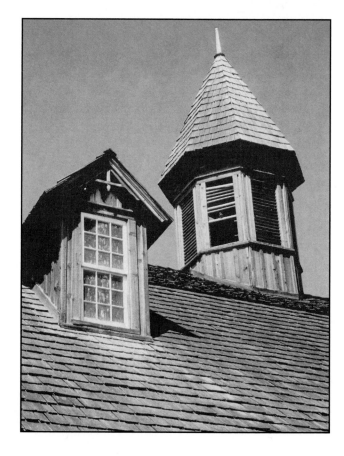

The octagonal, high-peaked turret on this Baker County, Oregon, barn is unusually tall. The double hung sash in the dormer window is of doubtful use, since access to it is a problem much of the time.

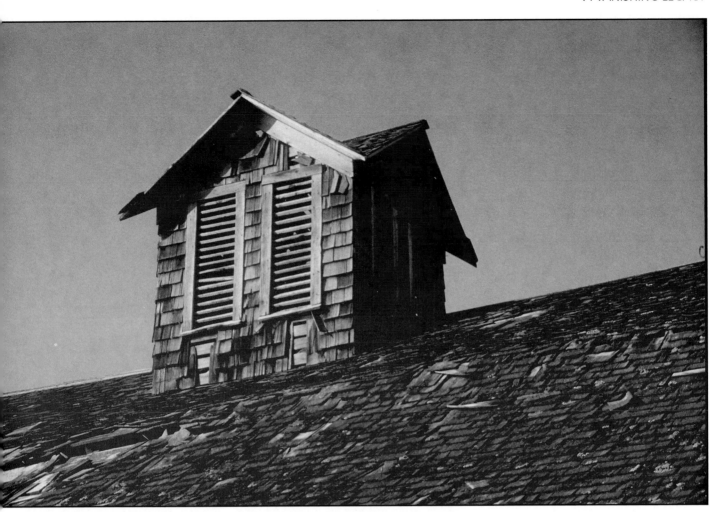

Wealthy Boise brewer John Lemp, a native of Germany, had a shingled turret placed on his barn in Ada County, Idaho.

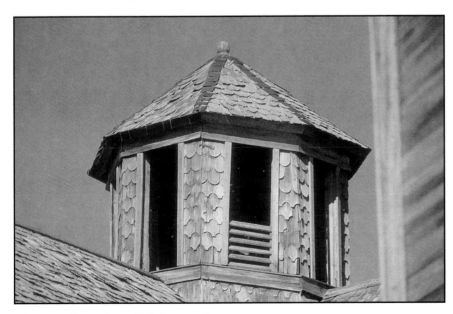

The great horse barn J.C. Bernard built for his Snake River ferry crossing in Owyhee County, Idaho, has fancy cut Queen Anne style shingles on its 1886 turret. Most of the louvers are gone.

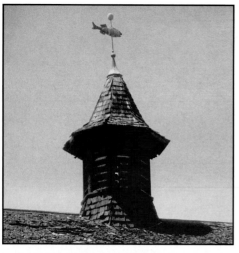

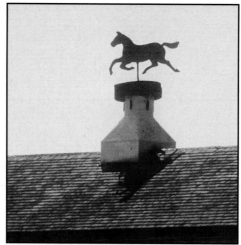

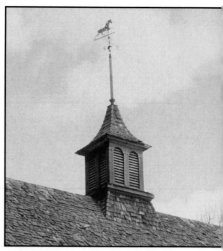

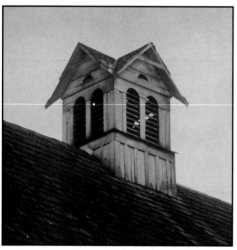

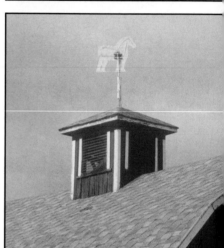

*The collection of turrets above,
reading left to right, are in Kittitas
County, Washington; Canyon
County, Idaho; Union County,
Oregon; King County, Washington;
Twin Falls County, Idaho, and
Whitman County, Washington.*

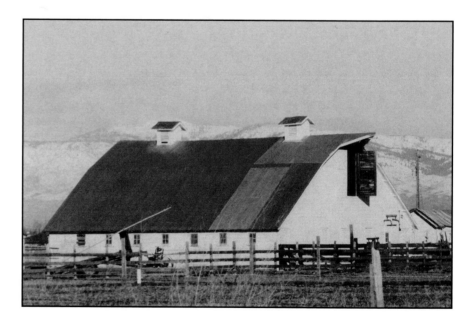

*Big dairy barns like this often had
two or more turrets.*

*Top of next page: The barn on the
Schulz Brothers Ranch in Sheridan,
Montana, has a variety of doors,
windows and dormers, in addition to
its turret.*

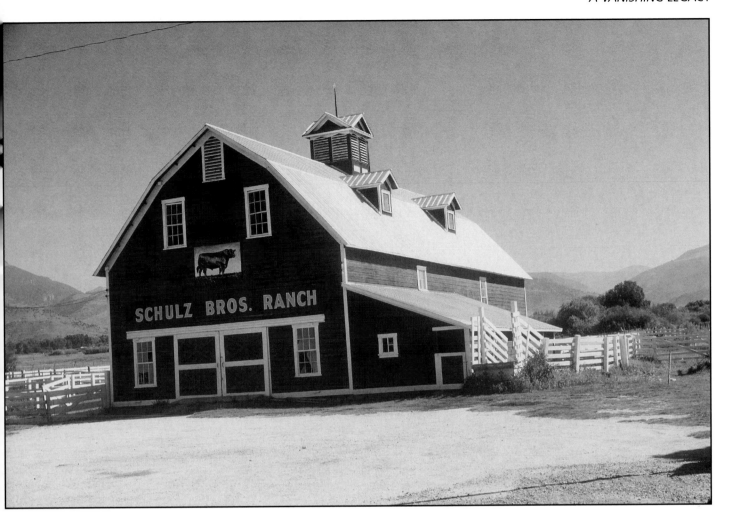

Windows

Barns often derive their individuality from the placement and number of windows. Early frontier barns had no windows at all, since the basic need was to shelter hay and livestock. Later ones could be elaborately lighted, even to the extent of building expensive but not very practical dormers. When the hayloft was full no light could get in.

The revolution that let natural light into barns all over the West was the availability of inexpensive glazed window sashes in standard sizes. These could be ordered from mail order catalogs or purchased at a nearby lumber yard. The spread of a railroad network into previously remote areas by 1920 was an essential factor in making manufactured goods of all kinds accessible to farmers and ranchers. Even earlier, after the main transcontinental lines were built,

freight wagons were completing delivery of such goods from supply centers along the lines.

The virtues of well-lighted barns as contributing to the health of animals was preached in many of the publications available to farmers after 1920, and was often linked to sanitation.

Some observers find amusement in "barn faces," since so many 20th Century barns have two eye-like windows in the top of the gable end and a door of some kind centered below in the position of a mouth. With some stretch of the imagination, these barns have the same look of mild consternation that the man-in-the-moon displays. A quirk of structural failure produced a locally famous "smiling barn" near Nampa, Idaho, that finally collapsed in 1995.

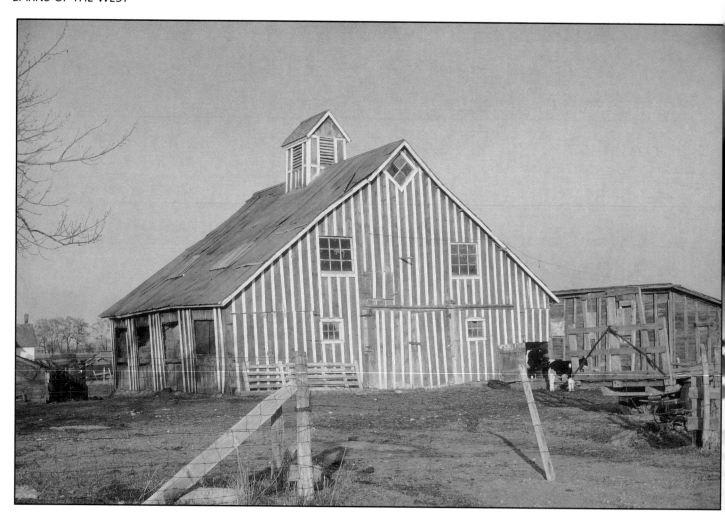

Weldon Fry's candy stripe barn has an unusual window at the peak of the gable.

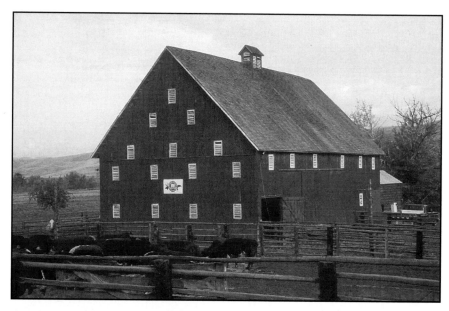

The century old Stewart Ranch barn near Dayville, Grant County, Oregon, is notable for the great number of louvered ventilators in its walls. It stands beside U.S. 26.

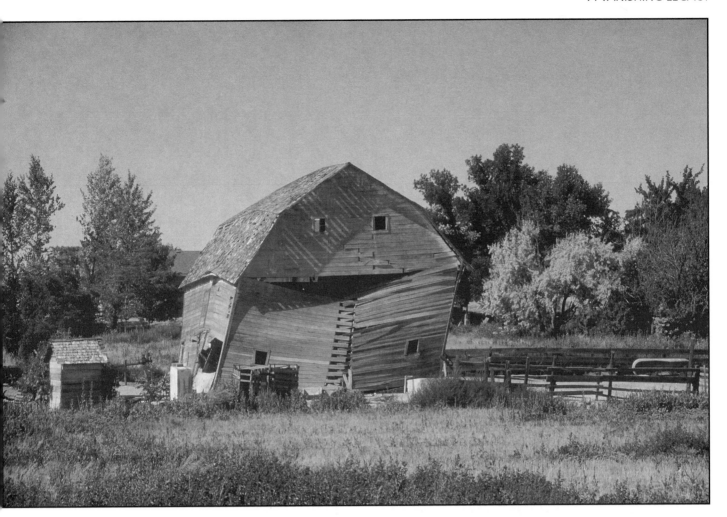

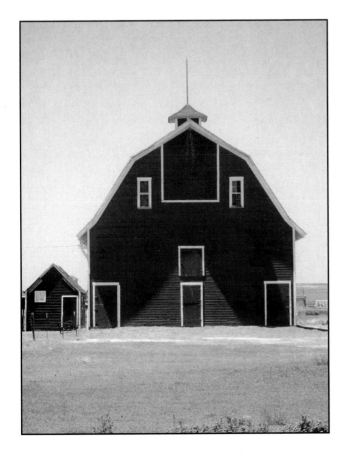

Top: Ben Korn's smiling barn near Nampa, Idaho, collapsed soon after this picture was taken. Left and above: How do you read these barn faces?

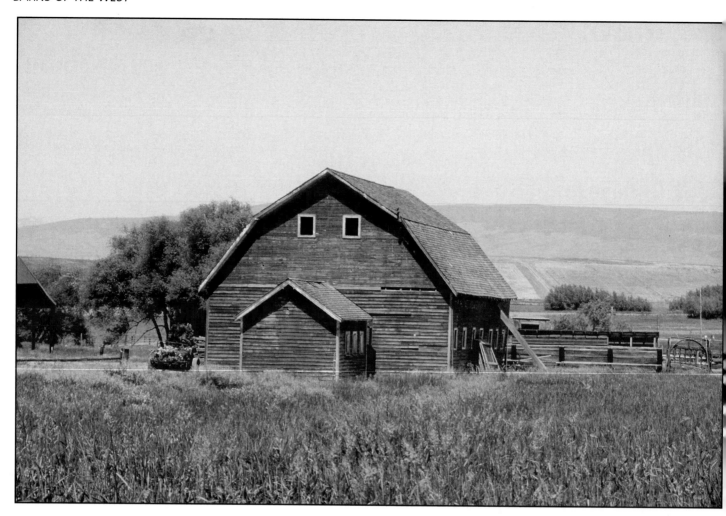

This "dog face" barn is in Kittitas County, Washington, south of Ellensburg.

Hayward, California, is the site of this very large stable with many windows and doors.

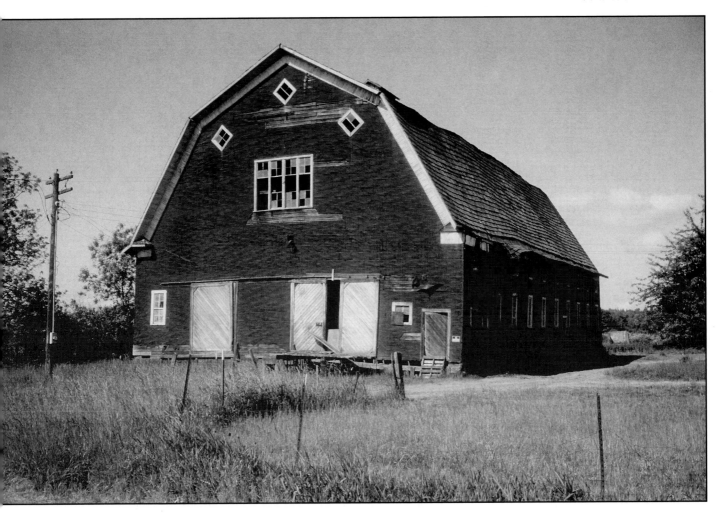

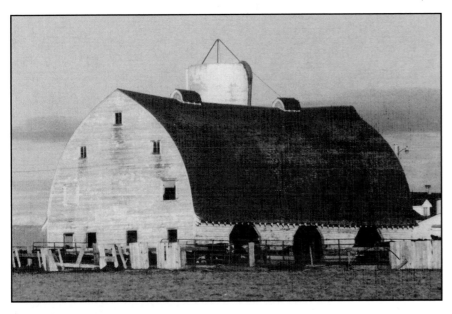

This dairy barn near Chehalis, Washington, has a unique set of windows. In cool, cloudy western Washington, many windows are highly desirable.

Windows follow the Gothic arched shape of the facade on a dairy barn in Canyon County, Idaho.

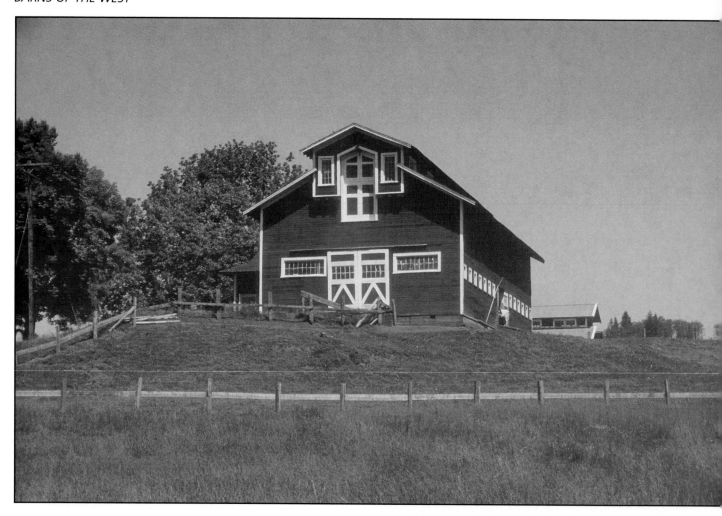

The Vetter Dairy barn, near Elma, Washington, has a unique arrangement of openings in its gable end, and long rows of windows along both sides where cattle are stanchioned.

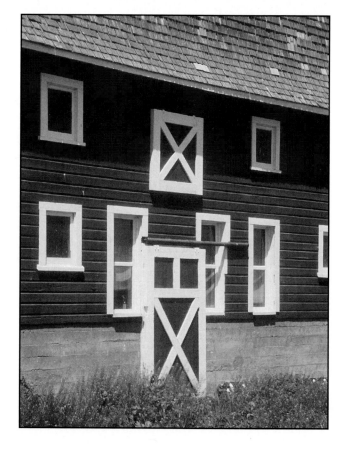

Arabian horses had luxury accommodations in the Jack Rose barn near Wilder, Canyon County, Idaho.

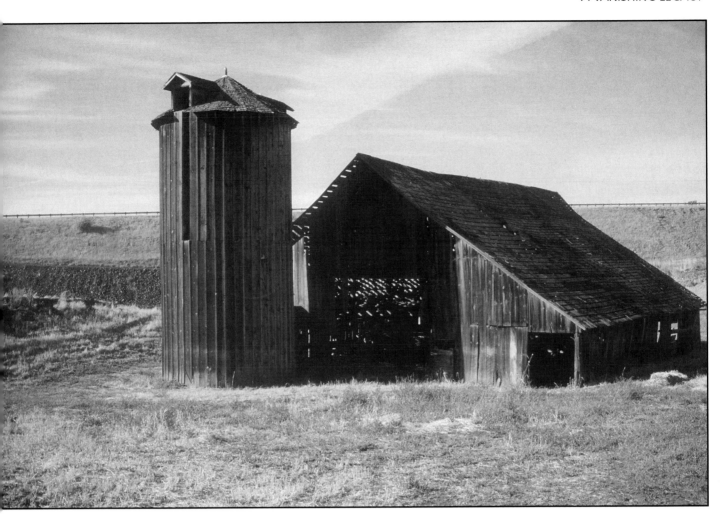

This wood framed silo and barn are in Nez Perce County, Idaho, not far from Lewiston.

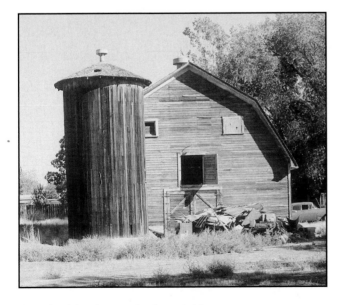

The silo, like the gambrel roofed barn, has a factory-made iron ventilator.

Silos

Silos, for the preservation and storage of fodder, were once a common adjunct of many western barns. The tall cylindrical form was a notable feature in any farmstead, but it too has become obsolete as technology continues to change. The earliest cylinder silos were built of wood, either with braced frames and vertical siding, or of 2 x 4 or 2 x 6 planks laid flat and built up with overlapping corners into hexagonal or octagonal towers.

Later, patented prefabricated silos could be ordered. Some were made of interlocking concrete blocks held together with iron hoops. Others, of enameled steel, were bolted together. Reinforced poured concrete silos, and brick or hollow tile silos are also familiar products of this century.

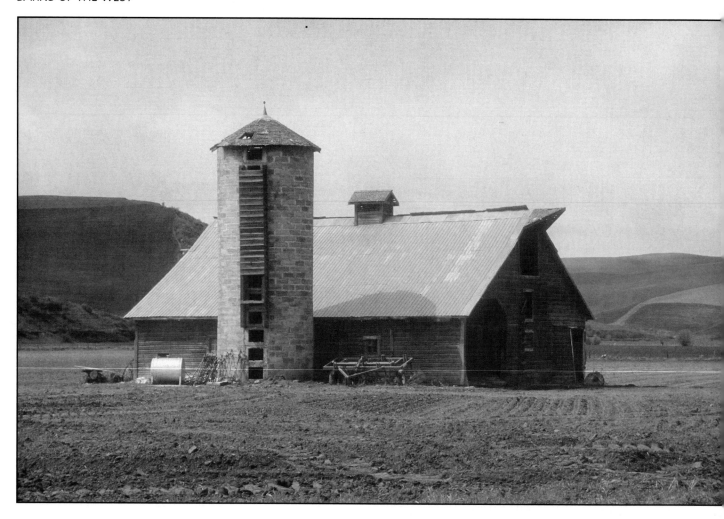

A masonry silo west of Dayton, Columbia County, Washington.

The old upright silos were hard to fill, and even harder to unload when everything was done by hand. Today, ensilage is handled with front end loaders and stored in long pits, or blown into long plastic tubes that can be left lying on the ground. The cylinder silo is becoming even rarer than the barn.

Patented interlocking concrete units are held together with iron hoops in this western Oregon silo.

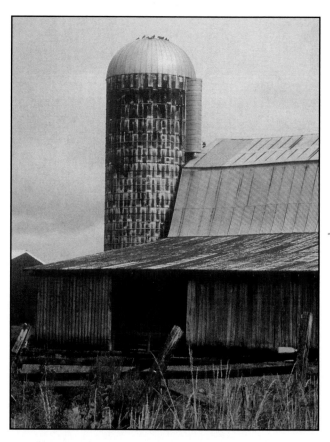

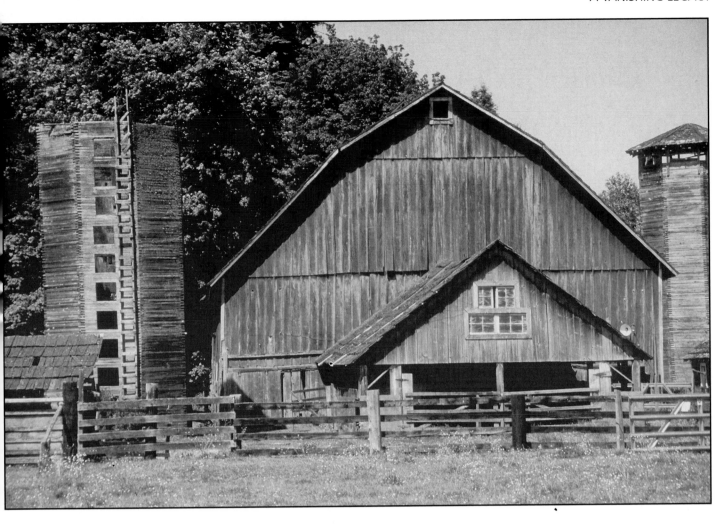

The Mouncier farm in Elma, Washington, has classic built-up wooden silos of the period 1905-10.

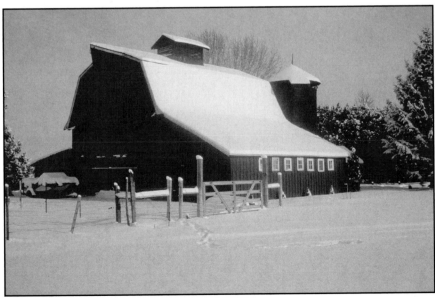

The Almon Spaulding barn and silo were built in 1910. They are among the last surviving farm buildings within the city limits of Boise, Idaho.

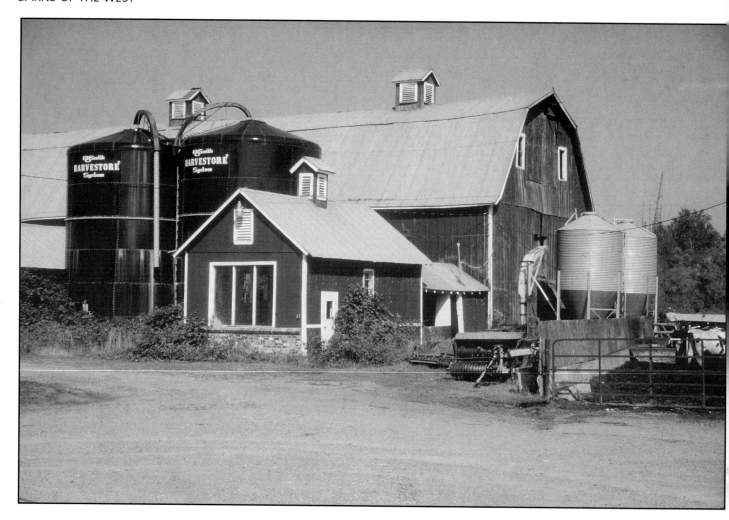

Manufactured enameled steel silos and storage bins, like these near Orting, Washington, have replaced nearly all of the wooden ones.

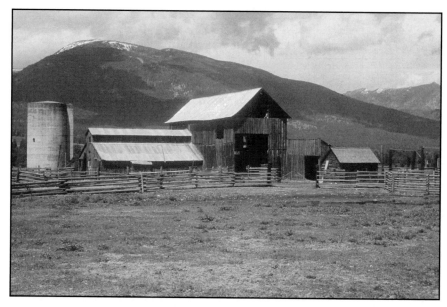

The big silo on this Ravalli County, Montana, ranch is made of poured concrete.

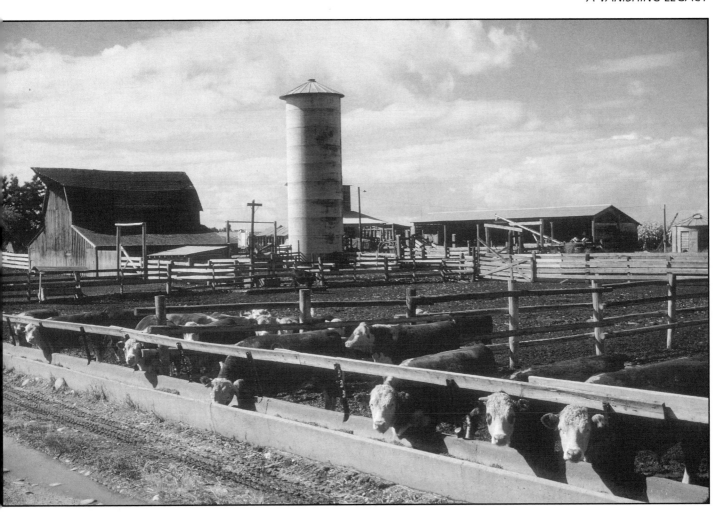

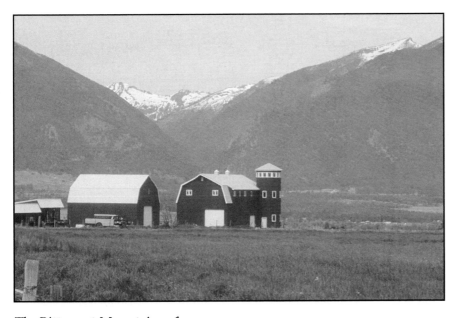

This Ada County, Idaho, ranch is now under development for housing. Its silo was concrete.

The Bitterroot Mountains of Montana provide a spectacular scenic view from the silo of a farmstead turned residence.

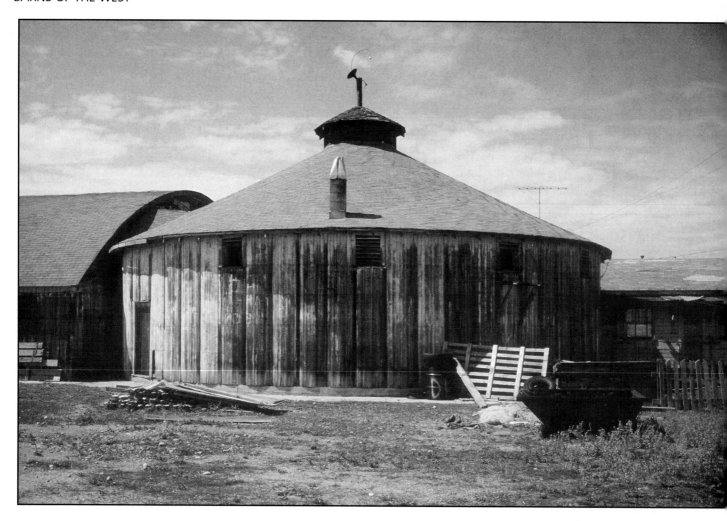

This round sales barn near Payette, Idaho, was the site of livestock auctions.

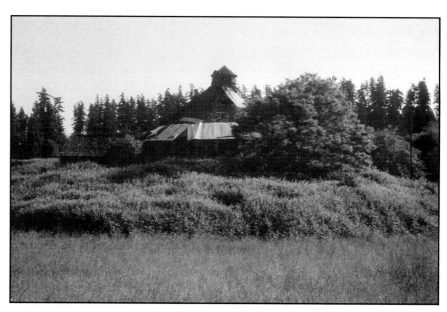

A western Washington round barn is decaying away under climbing vegetation.

Opposite page: The 1911 Leonard barn near Pullman, Washington, is a superb example of the type, although it has lost its cupola.

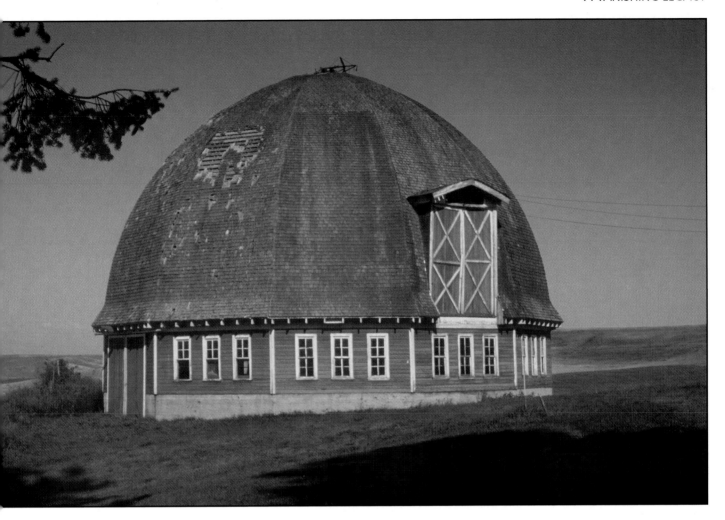

Round Barns

Round and octagonal houses and barns achieved some popularity in the United States and Canada after about 1860, partly due to the influence of Orson Squire Fowler, a popular phrenologist. His book *A Home for All, or the Gravel Wall and Octagon Mode of Building,* was published in 1853. Of the hundreds of round barns built in the 19th and early 20th centuries only a handful remain. There are probably fewer than a dozen still standing in western states. The author followed every published reference in his search for round barns in the West, only to find again and again that the structure had burned, had blown down in a storm, or had been demolished by its owner. Most of those found were in poor condition or threatened by development.

George Washington may have built the nation's earliest round barn in Fairfax County, Virginia, in 1793. It no longer exists, but the great stone barn built by the Shakers at Hancock, Massachusetts in 1824 is one of America's best-known buildings. It has been suggested that for the Shakers, the Amish, and other religious sects that established Utopian agricultural communities to shelter their religious beliefs and life styles, the circle had special spiritual or mystical significance. The circular decorations on Pennsylvania barns, usually created with compass arcs inside a circle, were first labeled "hex signs" by Wallace Nutting early in this century. They were believed to ward off evil spirits or to bring good luck. Although some present day authorities agree with this interpretation, others insist that the signs were merely decorative in purpose. Certainly round boxes, round hats, round rugs and round patterns in quilting

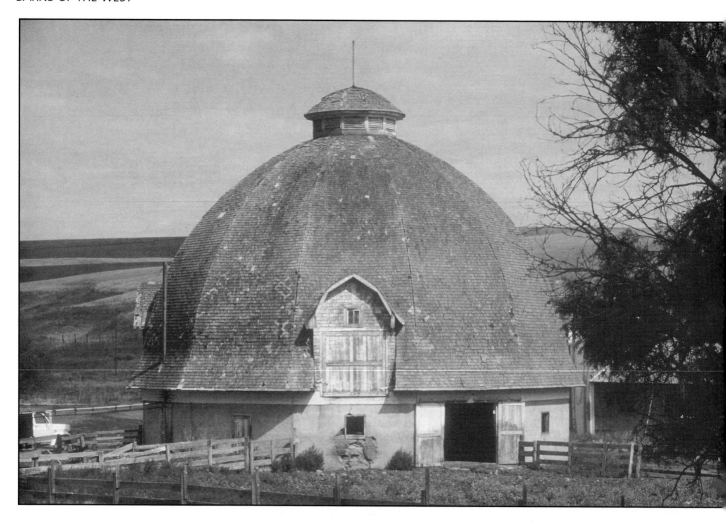

Max Steinke's 1916 round barn is west of St. John, Washington. It and the Leonard barn of five years earlier are both in Whitman County. Their roofs are often called campaniform, or bell-shaped.

Above and next page: Interior views of the Steinke barn show the overhead trolley and a horse stall.

designs were used by these same sects, whether for their religious significance or "chust for pretty" as Eric Sloane writes in his popular *An Age of Barns.*

The circle has had special meaning to cultures worldwide since prehistoric times, perhaps directly related to the round face of the sun that warmed the earth and made life possible. We do know that in nearly every prehistoric culture, the first dwellings, whether of stone, wood, or bent saplings, were round in form, as were the pit houses, hogans, rush mat tepees and wickiups of many Western Indian groups.

Some builders of round barns may have been looking simply for novelty — a barn different from that of their neighbors, or they may have believed strongly in the practicality of the round form. A circular wall encloses more space for the amount of material used than a rectangular one. A round structure 100 feet across, like Peter French's famous horse barn south of Burns, Oregon, encloses an area of 7,854 square feet. Its outer wall is 314.6 feet long. A rectangular barn, with walls totalling that length, encloses only 6,185.8 square feet, or 22 percent less.

Typically, round barns had stalls for the animals facing the central core, so that hay or fodder could be pitched into the mangers from the loft above, with an economy of movement. This is certainly a practical consideration. So-called round barns, like Max Steinke's in Whitman County, Washington, are most often hexagons, or decagons, again for purely practical reasons. Straight wall sections are infinitely easier to build than curved ones, although that feat was accomplished occasionally. The Steinke barn, built in 1916, has poured concrete floors and lower walls, and an overhead trolley to carry a manure car to an outside pile. Concrete manure troughs made

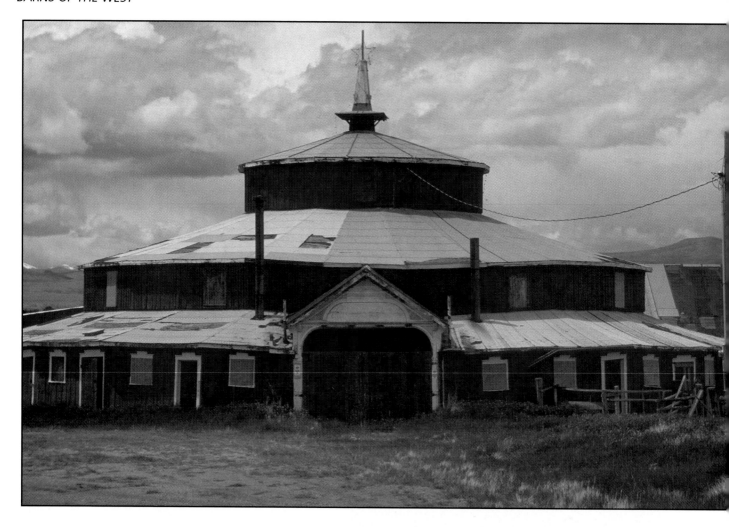

The Byron Byers ranch near Twin Bridges, Montana, has one of the largest round barns left in the West.

mucking out and hosing down much easier and more sanitary than the wooden floors of earlier barns.

The few round barns left in the West need to be carefully documented, for unless new uses are found for them, our rural landscape will have lost some of its most picturesque and evocative landmarks. Fortunately, some barns have been listed in the National Register of Historic Places, and local preservation groups are interested in their future. Because they are a novelty, round barns have been the subject of many feature stories in newspapers and magazines across the country. Hopefully, the heightened public awareness created by these articles will help in their preservation and restoration.

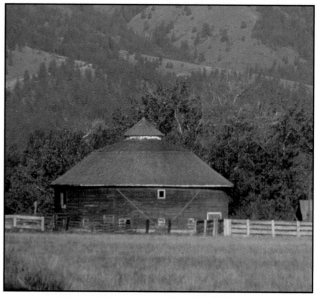

Alphon Wayne Courtney built his stud-framed round barn near Lostine, Wallowa County, Oregon, in 1925. The lap siding was bent to follow the form.

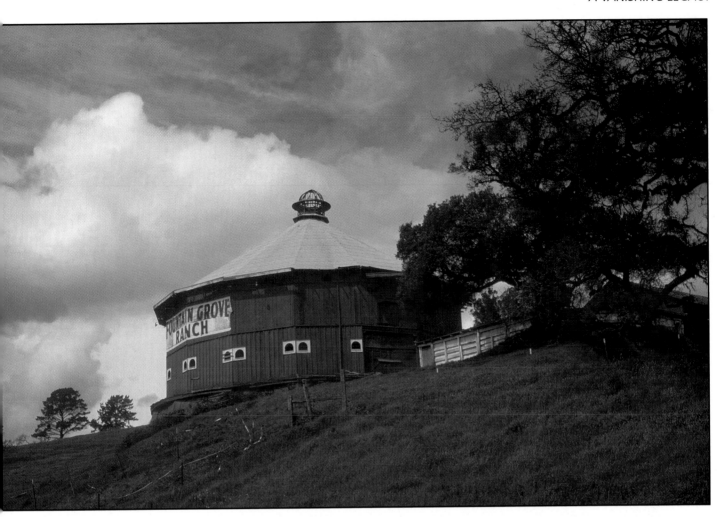

Fountain Grove Ranch near Santa Rosa, California, boasts that state's most famous round barn. It was built in 1898 for the utopian community of Fountain Grove.

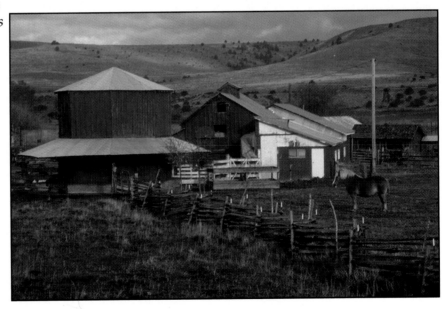

A few octagonal barns still stand in Oregon. This small one is on U.S. Highway 26.

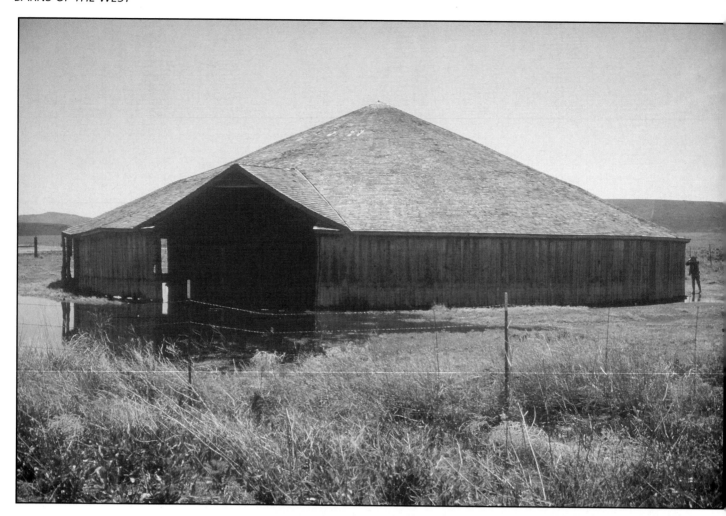

Oregon's most famous barn is listed in the National Register of Historic Places. Cattle baron Peter French built it in 1883 for training and exercising horses. It is located southeast of Burns.

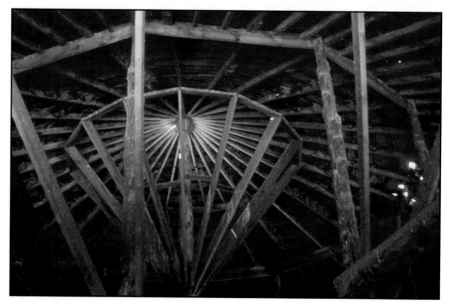

The spectacular framing of the French barn is its most notable feature. The posts are native juniper.

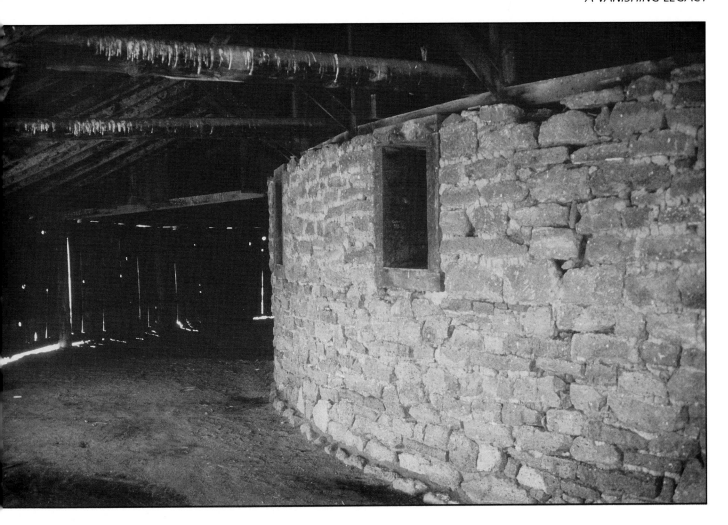

A stone corral 64 feet in diameter, inside Pete French's round barn supports posts for the roof trusses.

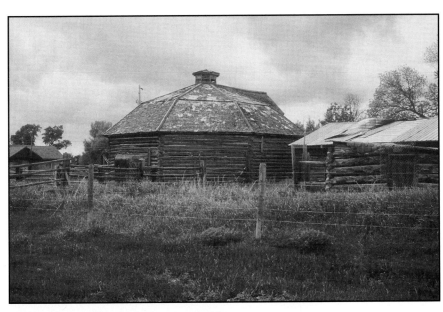

This octagonal log barn is on a ranch near Waterloo, Madison County, Montana.

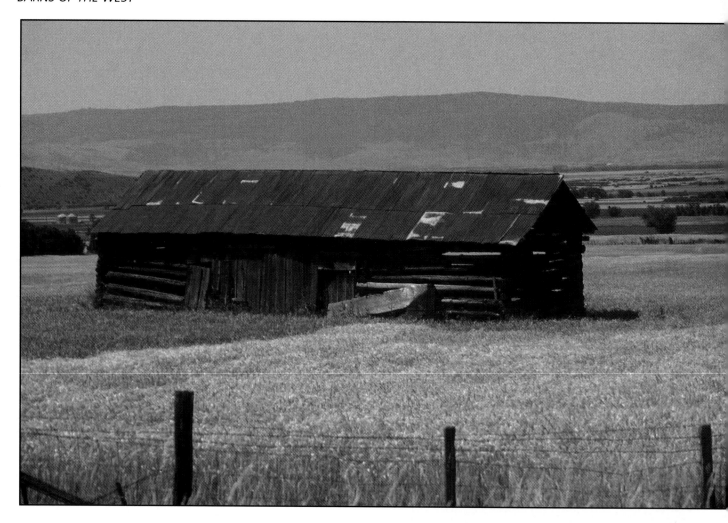

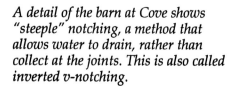

A double crib log barn near Cove, Oregon. Two equal sized square log cribs are on either end of a threshing floor, all under one roof. This ancient plan creates a breezeway between the cribs, allowing chaff to blow away as grain is threshed with hand flails, or by having animals driven over it. The threshing floor on this example has been enclosed.

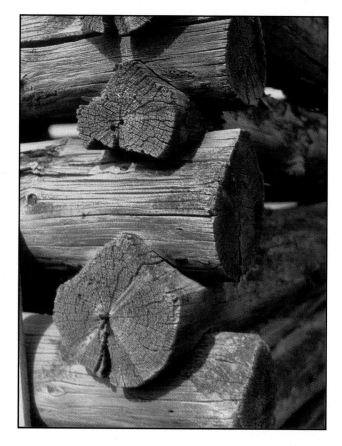

A detail of the barn at Cove shows "steeple" notching, a method that allows water to drain, rather than collect at the joints. This is also called inverted v-notching.

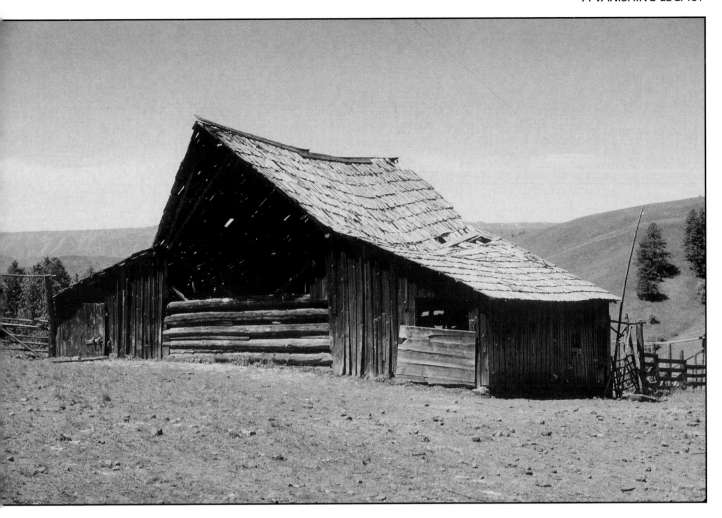

Log Barns

Throughout the West, especially in mountain regions where timber was plentiful, log barns were built. In the Rockies, where lodgepole pine is common, a distinctive lodgepole culture developed in which the long, straight, and slender poles were used for fences and gates, and for the rafters, joists, and walls of log buildings. The "beaver slide" hay stacker, still used in some intermountain valleys, was also made of lodgepoles.

Because they are so slender, lodgepoles provide little insulation in walls, and heavier logs of ponderosa pine or Douglas fir were preferred, especially for log dwellings. If the thicker logs were used for the walls, the much lighter lodgepoles were preferred for the roof structure.

Joseph Plain is a high, narrow plateau between Salmon River and Hells Canyon of the Snake. This log barn uses both ponderosa and lodgepole logs, and has a roof of split shakes.

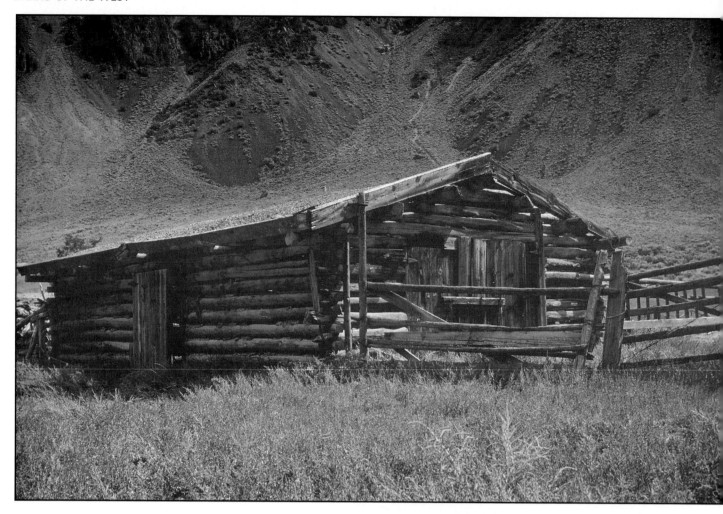

Log barns along the upper Salmon
River are often roofed with poles edge
to edge and covered with straw and
earth.

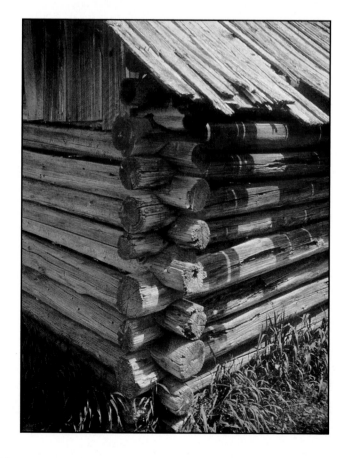

This steeple-notched log barn in
Granite County, Montana, with its
roof of boards laid vertically, was
primarily built to furnish winter
shelter for open range livestock.

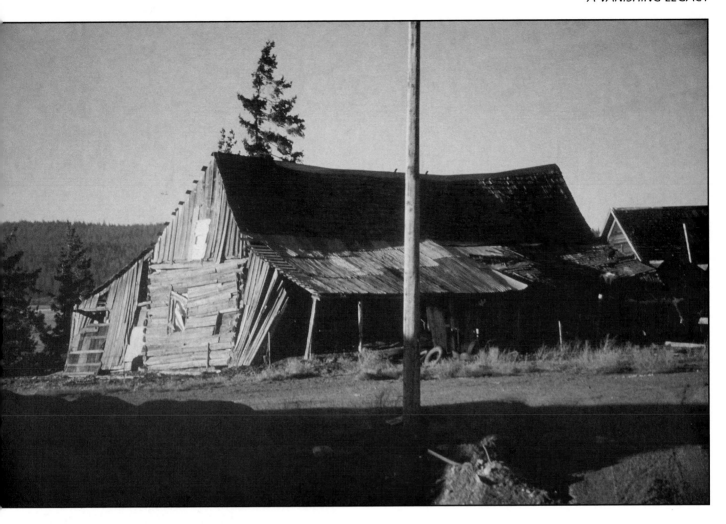

On a high ridge, next to Interstate 90 north of Thorp Prairie, Kittitas County, Washington, this ancient log barn is slowly sinking into the earth.

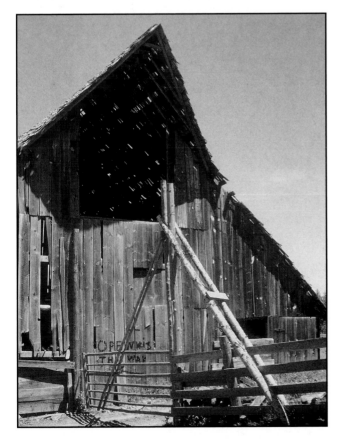

Lodgepole technology is well illustrated in this gate next to an Idaho County, Idaho, barn. The roof structure is all framed with the slender lodgepoles.

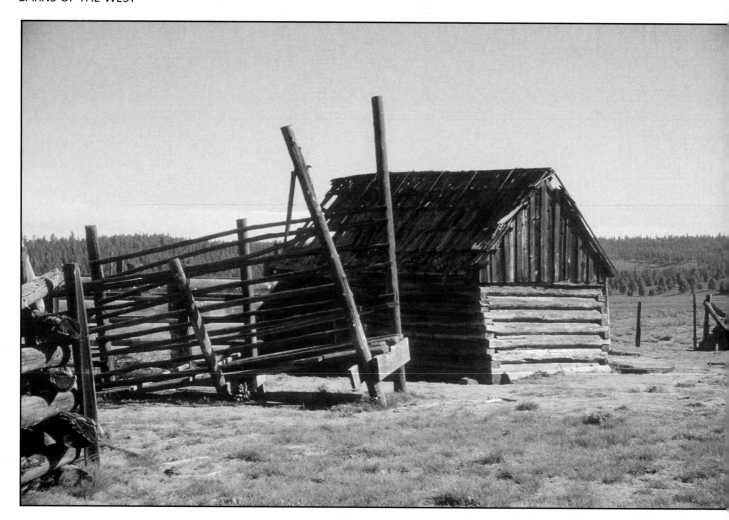

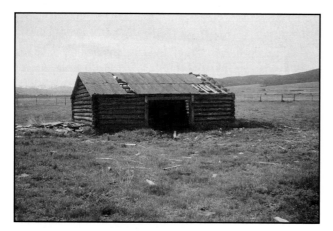

Top: Fence, loading chute, and barn are part of a log complex in Bear Valley, Grant County, Oregon.

Above: This log double crib barn is in Granite County, Montana. Compare it with the Cove, Oregon, example on page 72, a detail of which is shown at right.

Cove, Oregon, double crib barn.

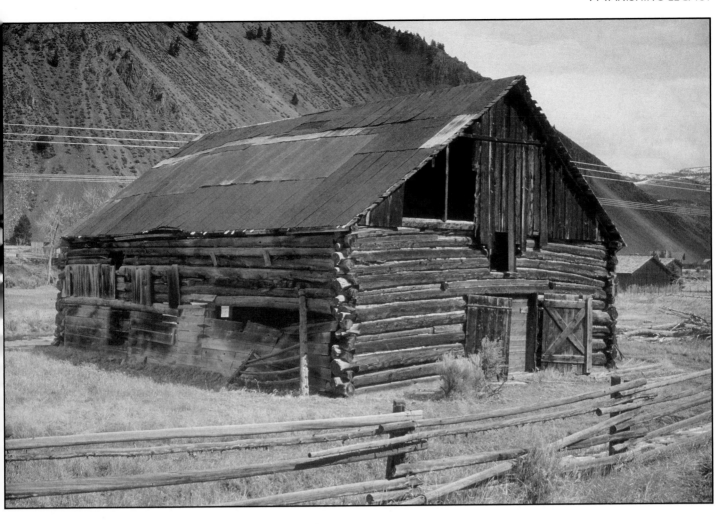

A big log barn on the upper Salmon River, Custer County, Idaho, has survived because of its iron roof. It is near Thompson Creek on Idaho 75.

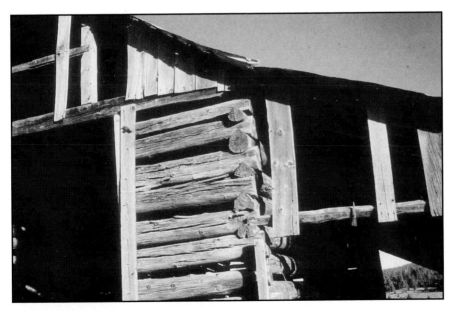

Some of the logs in this old barn in Drews Valley, Lake County, Oregon, were hand hewn. Others were left round.

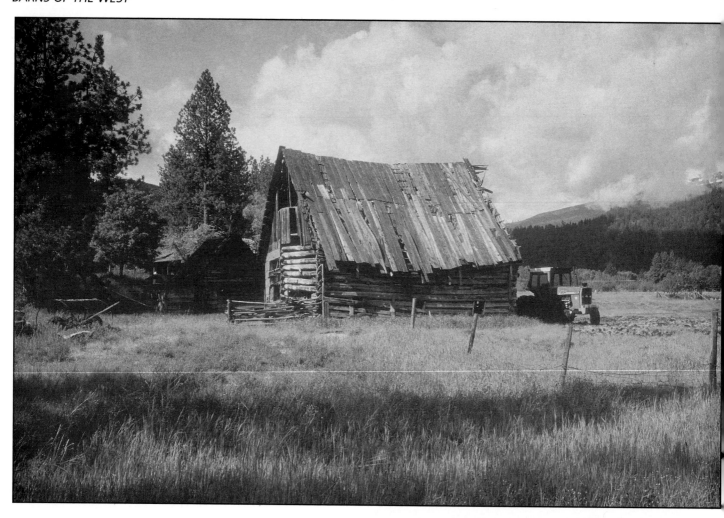

An upper Bitterroot Valley barn
near Conner, Montana, is a
photographer's delight.

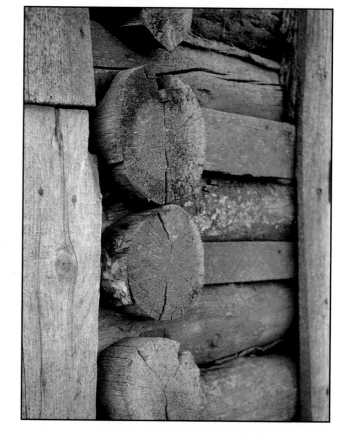

Detail of a log barn on Squaw Creek,
Gem County, Idaho. Cracks between
logs have been chinked with wood.
Lichens add their own rich patina.

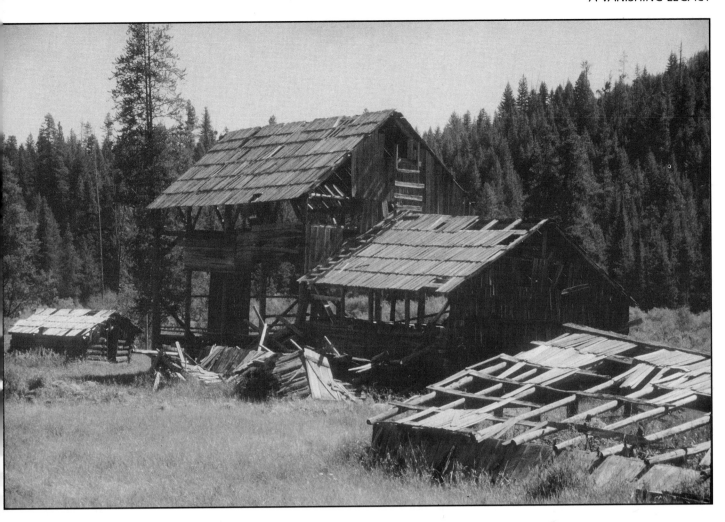

*One of the last old barns on Lolo
Creek, U.S. Highway 12, between
Lolo Pass and Missoula, Montana.
It can't last many more winters.*

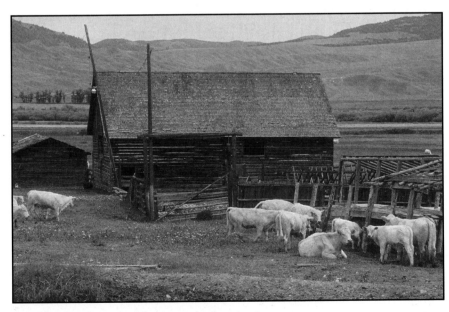

*Deer Lodge County, Montana, is the
site of this cattle ranch log complex.*

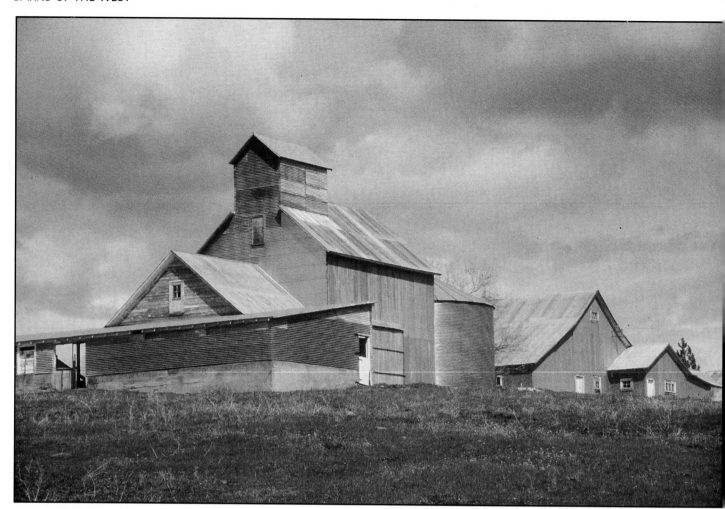

Some western barns and
outbuildings have been sheathed
entirely in corrugated galvanized
sheet iron — effective but
hardly esthetic.

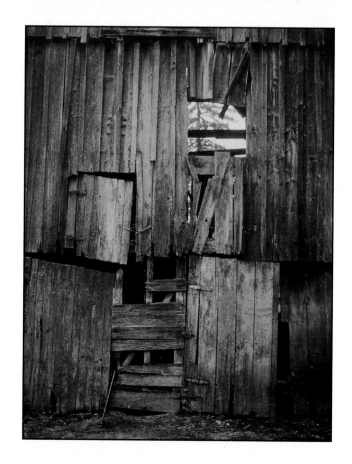

It rains a lot in Pedee, Oregon,
and this old barn shows the warm
texture of lichens provided by nature,
"a sea change into something rich
and strange."

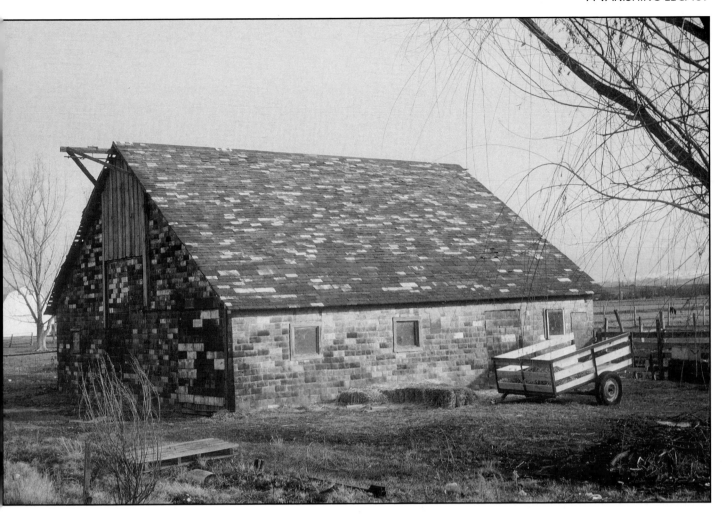

Surfaces

Getting really close to an old barn reveals the detail and texture that make it individual. The hand of man vies with the hand of nature in gradually changing wood and iron into new configurations. We find character in the surfaces of an old barn just as we find character in the wrinkled and weather-beaten face of an old cowboy. The constant theme is change through time.

Flattened motor oil cans cover this Canyon County, Idaho, barn near Star. You can still read the brand names despite the rust.

Boistfort Valley, in Lewis County, southwest of Chehalis, Washington, was once a leading hop producing area. Today, not a trace of that industry remains, but this barn is one of the few you will see sheathed in western red cedar shingles.

81

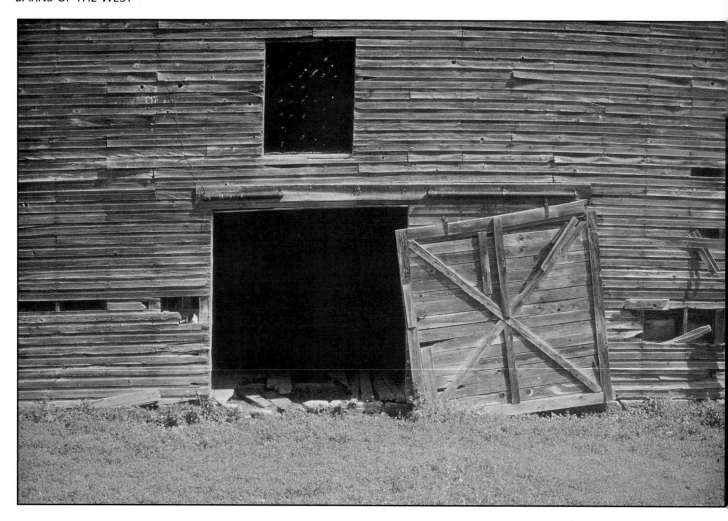

The ghosts of humans and farm animals seem to linger around decaying barns like this one in western Montana.

There is no suggestion here that the board and batten barn ever had a coat of paint, but it might have.

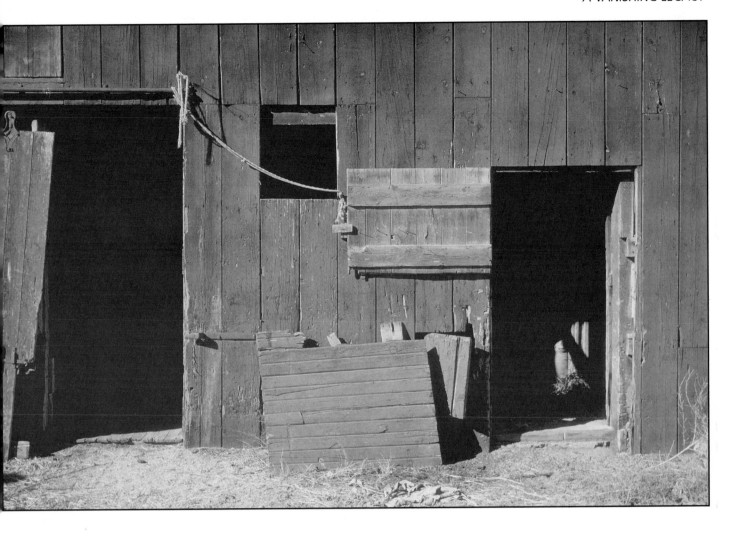

Nostalgia lingers around this deserted barn, with its doors falling off.

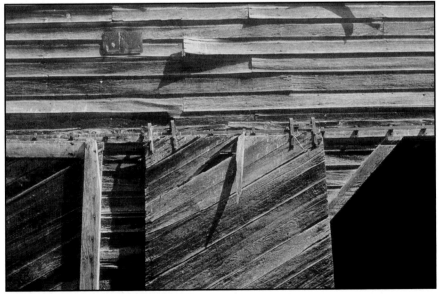

Warping, fading, and rusting.

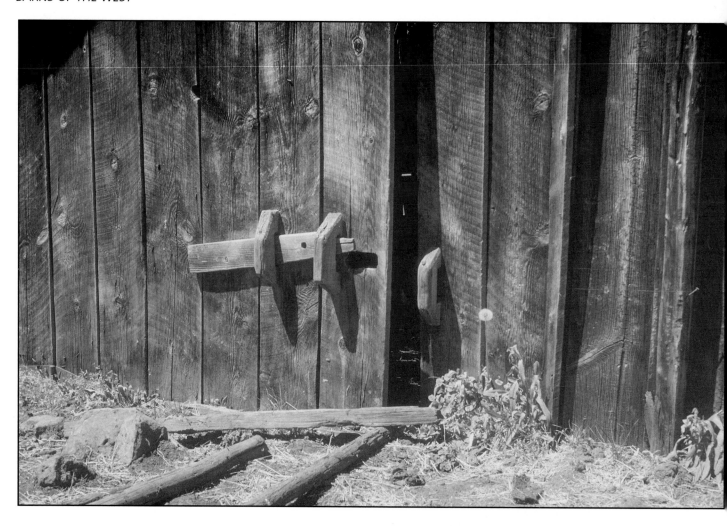

A homemade wooden door bolt reminds us of the maker.

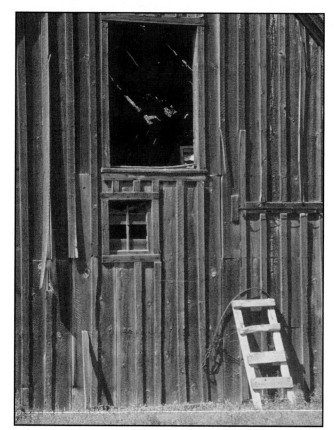

This ladder won't quite reach.

Aging wood and iron — the stuff old barns are made of.

Windmills add picturesque silhouettes to ranch scenes, like this one from eastern Oregon.

Mike Hanley's Jordan Valley, Oregon, barn is decorated with the ranch's historic brand and an old oxbow. Cowboy writer Hanley has published several books about the range country where Oregon, Idaho and Nevada meet.

A widely read farm and ranch magazine posted signs on barns across the West, as did many other advertisers.

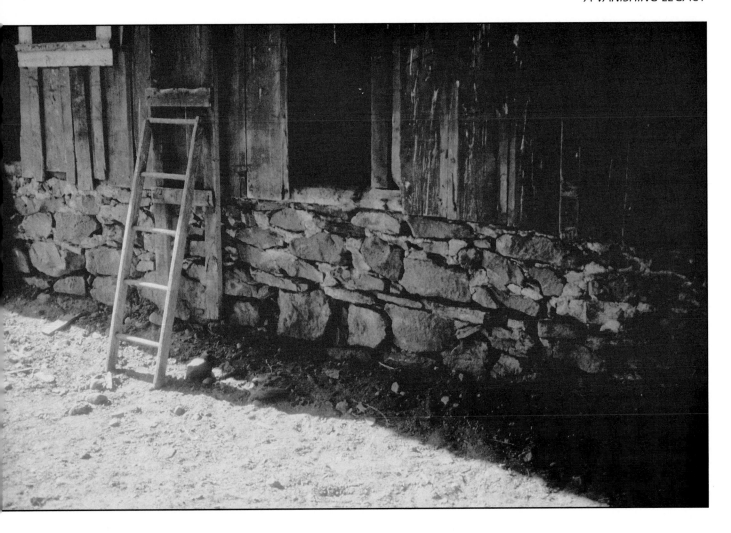

This ladder in a barn near Lostine, Oregon, is just long enough to surmount the stone foundation.

Local stone makes up the fabric of Alex Canter's 1871 barn near Jordan Valley, Oregon.

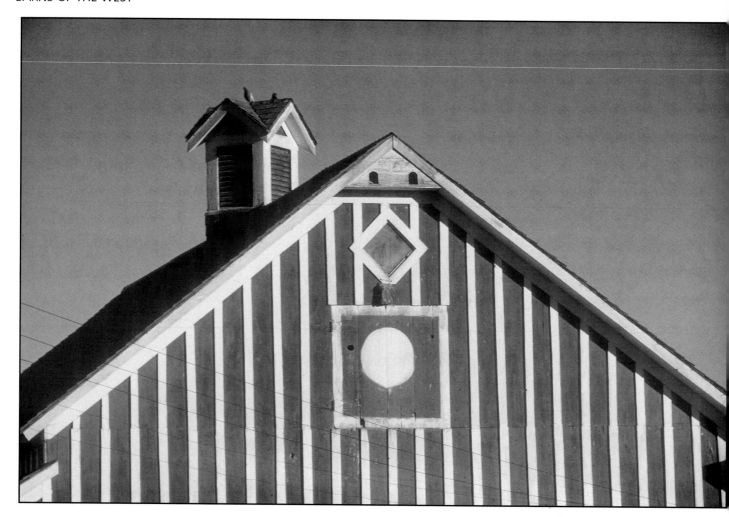

The turret on this Ada County, Idaho, candy striper was made by a Missouri carpenter and shipped to a former Missourian who wanted one "just like the one on the old place."

This positive-negative optical illusion can be read as wide red battens on a white barn.

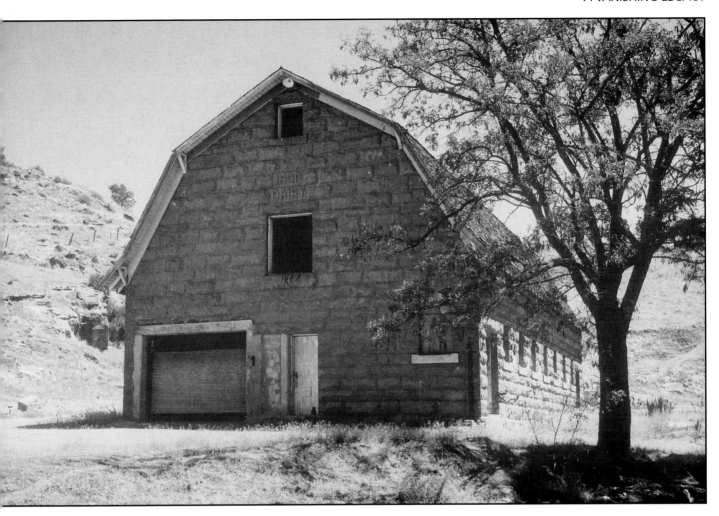

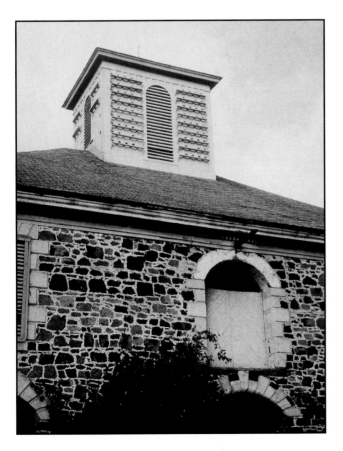

Stone barns are rare, except in country where trees are scarce and stone is plentiful. In 1920 a stone dairy barn was built at the Idaho State Penitentiary utilizing stone from the quarry nearby.

This superb Sonoma County, California, stable has a very large louvered turret.

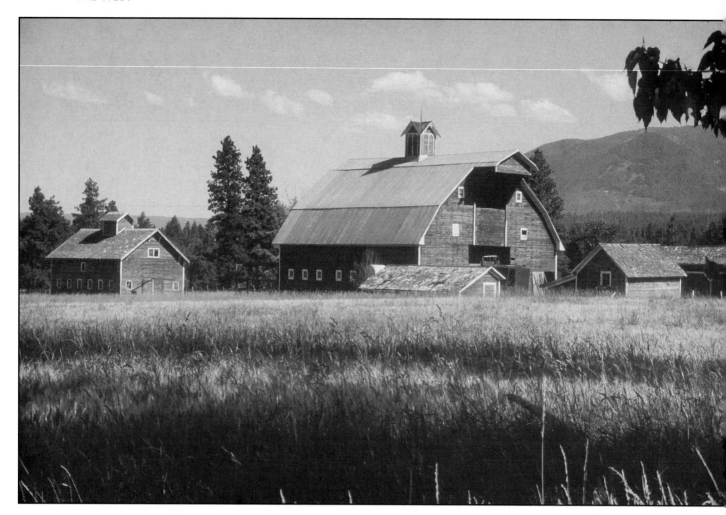

Alder Slope, near Enterprise, Oregon, has dozens of handsome barns in a beautiful mountain setting.

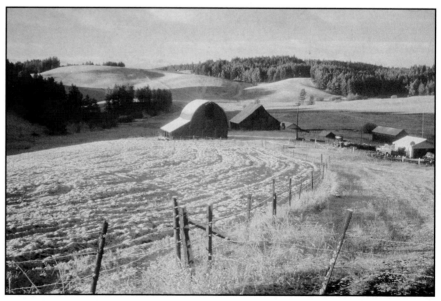

The rolling country around Keuterville, Idaho, was settled by German immigrants. After a late spring snowfall the prospects are grand.

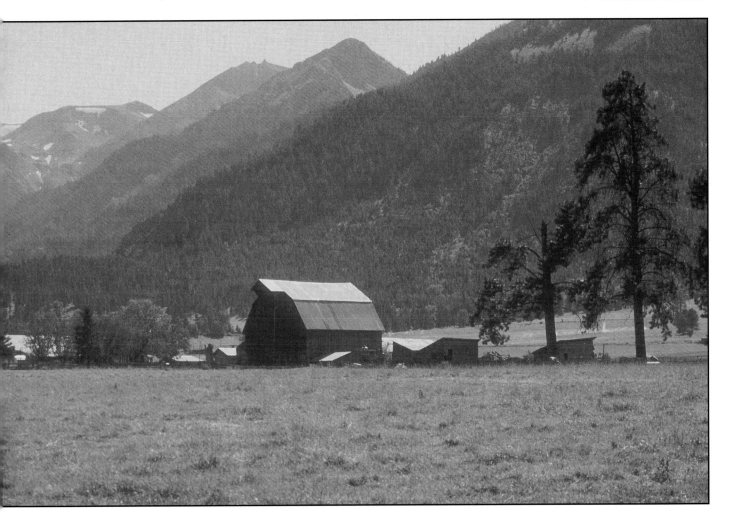

The Landscape

The photographer and historian seeking out old barns along the backroads finds natural settings that add to the variety and beauty he seeks. The American West, with landscape ranging from alpine to desert to coastal wetlands, with transition zones between, has an incredible variety of sites for barns. In wet lowlands west of the Cascades and Sierras wood rots faster than on the high desert, and lichens and moss cover walls and sagging roofs. In mountain valleys of Idaho and Montana nearly everything is built of logs or poles, and snowcapped peaks form a scenic background for much of the year.

Top: The Wallowa Mountains rise grandly behind this farm near Enterprise, Oregon.

Above: The coastal plain near Eureka, California, is home to several old farms with huge gable barns.

91

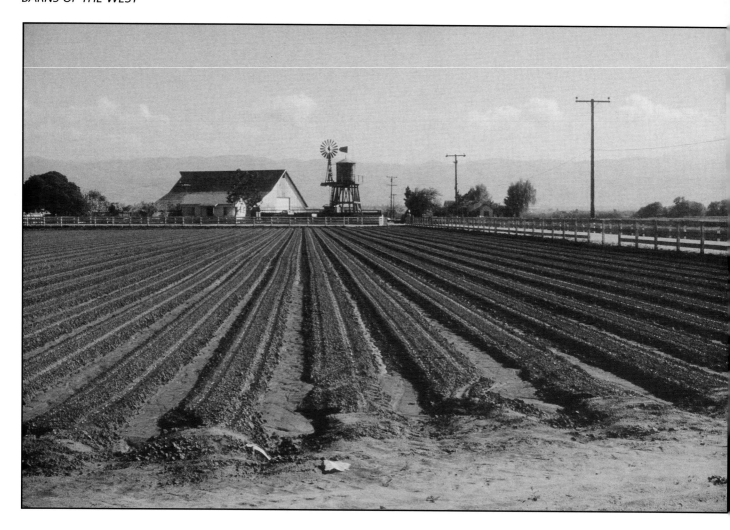

The great central valley of California is one of the most productive agricultural areas in the world.

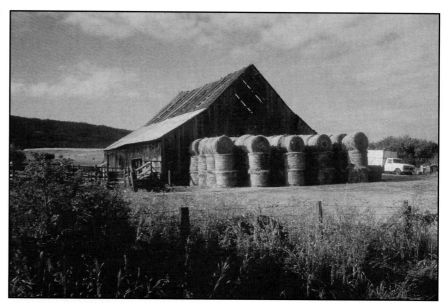

Rolled hay bales piled in front of an old long hay barn near Grangeville, Idaho, make an interesting contrast.

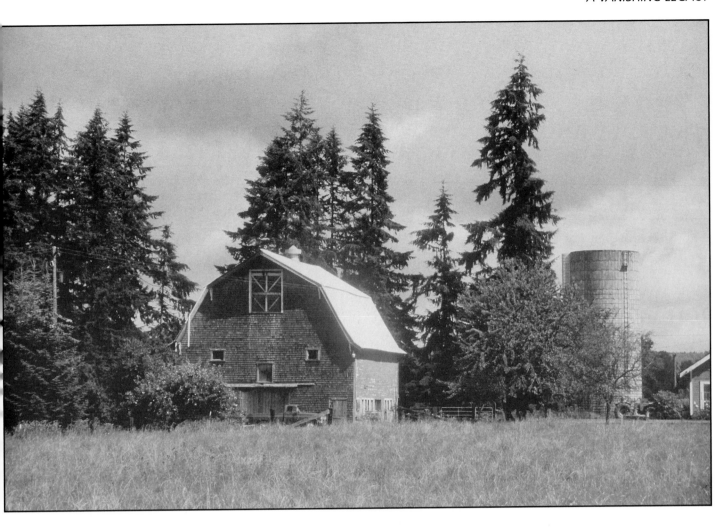

The distinctive silhouettes of tall
Douglas fir trees set off farmsteads
in western Washington.

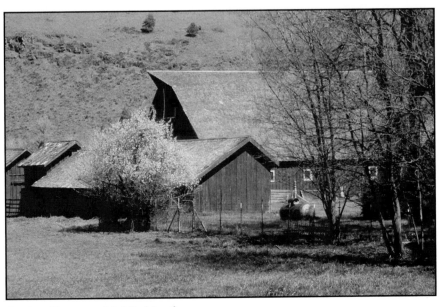

Spring blossoms highlight a farm
setting in the John Day River valley
of Eastern Oregon.

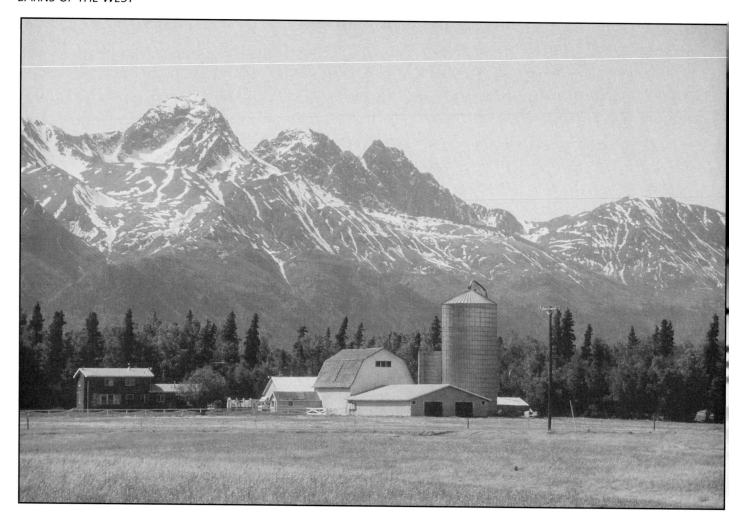

The Chugach range forms an awesome background for dairy farms in Alaska's Matanuska Valley.

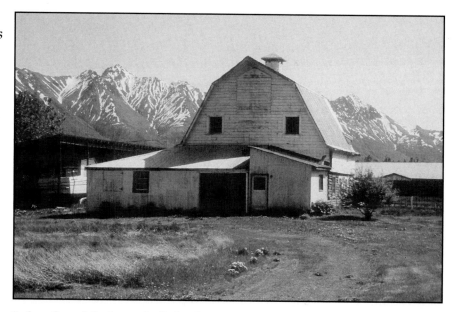

Only a few of the barns built by the federal government for Matanuska colonists in 1935 remain. Some are well maintained.

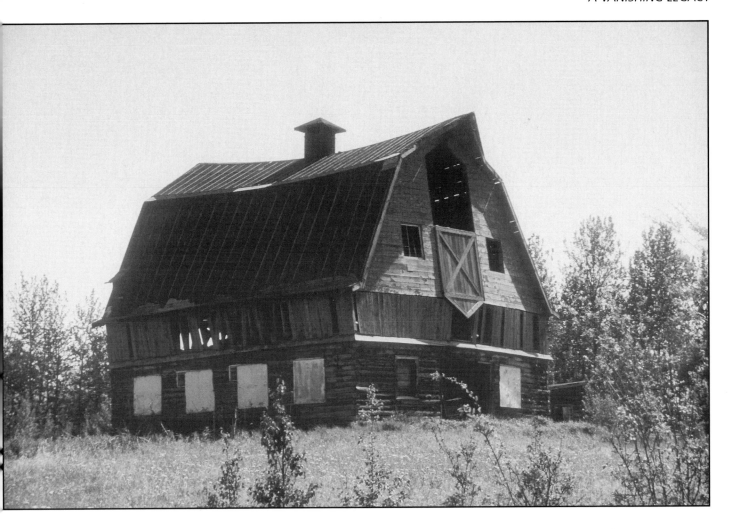

Alaska

In the late spring of 1935 200 families
arrived by government transport in
Anchorage, Alaska — first colonists in a
New Deal experiment to relocate farmers
from desperately depressed rural areas of
Michigan, Minnesota and Wisconsin. All
had been on welfare. The plan was to make
them self sufficient, productive farmers
again, and to colonize Matanuska Valley
east of Anchorage, a fertile but largely
forested area with only a three month
growing season, but with 20 hours of
sunshine on summer days.

By December 14, 1945, thanks to a crash
building program using WPA carpenters
and helpers from California, 101 barns had
been built, using logs harvested as the
spruce forests were cleared for farming.
Many families found their first Alaskan
winter, and the prospect of successful

*This 1935 partly log barn still stands,
but not for long.*

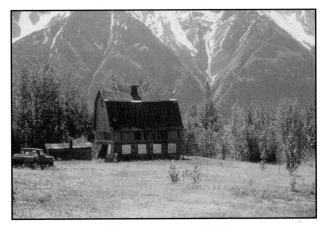

*The same barn with the mountain
wall behind it. It has survived half a
century of Alaskan winters.*

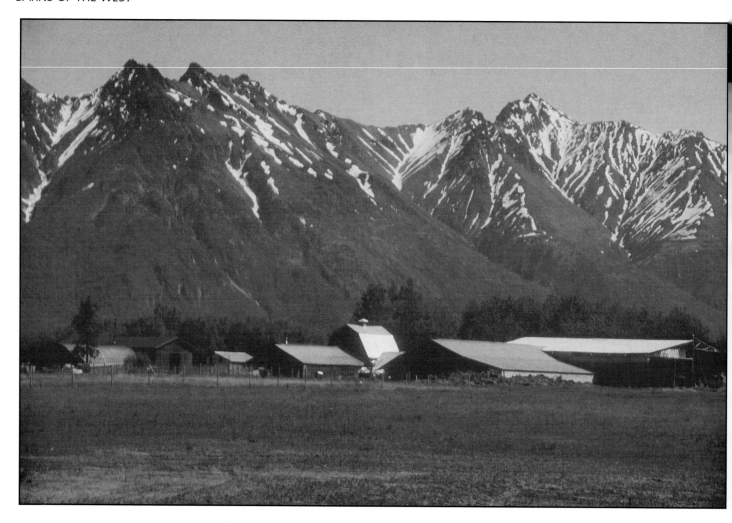

farming at this latitude, too discouraging and left. Others from the states replaced them.

As the threat of war with Japan led to a massive buildup of U.S. forces in Alaska, with Anchorage as the center of activity, road and rail connections with Matanuska Valley gave the settlers a ready market for produce. Cabbages of prodigious size, potatoes, beets and rutabagas with high yield per acre, drew national attention, but dairying turned out to be the valley's most profitable industry. Booming Anchorage, with its expanded military and civilian population, took all the milk the area could supply. By 1943 there were 700 dairy cows, mostly Guernseys. Twenty years later the industry was still growing as more land was cleared for hay and pasture. Holsteins and Red Danes were the preferred breeds by that time.

Nearly all of the open farmlands in Matanuska Valley had to be cleared of dense spruce forest before crops could be grown.

The original colonists started with 40 acres per family. Today many of the farms have more than 500 acres, but not all of it is cleared. With this combining of many small operations into large and more efficient ones, Matanuska's first log barns have nearly disappeared. Those that remain in this unique agricultural valley are relics of a great experiment that eventually paid off for those who stuck it out.

Top right: Puyallup Valley, Washington, was one of the nation's top hop producing regions in the 19th Century. Most of its picturesque hop driers have disappeared.

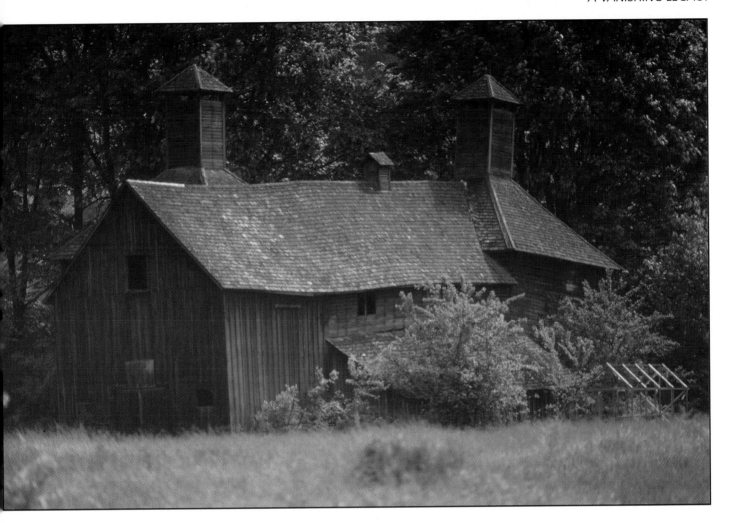

Hop Barns

Technically, oast houses or hop driers are not really barns, because they do not shelter animals or hay. However, these specialized structures are so widely known as barns, and are such a striking feature in the landscape that they can hardly be omitted from a book like this.

Hops are the cone-like seed clusters of the perennial vine *Humulus lupulus,* used to flavor beer. In the 19th and early 20th Centuries the annual late summer hop harvest was a social occasion for western Indians, who gathered from as far away as Alaska, and for city families who saw it as a camping out adventure before the children went back to school. The festive nature of the hop harvest is attested to by many historic photographs of large groups of pickers, festooned with vines, posed before a hop barn. Children of all ages in these pictures suggests that it was truly a family outing.

The hop barn, or oast house, had as its function drying the green hop cones before they were baled and sent off to breweries for use as flavoring — a value that has been appreciated by brewers since Roman times. The distinctive visual feature of hop barns built before 1919, when the enactment of Prohibition wiped out the American brewing industry, is their tall ventilating towers, mounted on pyramidal roofs. The green hops were spread on a square drying floor of a mesh material to a depth of about eight inches. Hot air, produced by a wood burning furnace in the room below, rose through the hops, releasing clouds of steam through the ventilator tower. The western valleys of Washington, Oregon and California were once dotted with these tall-

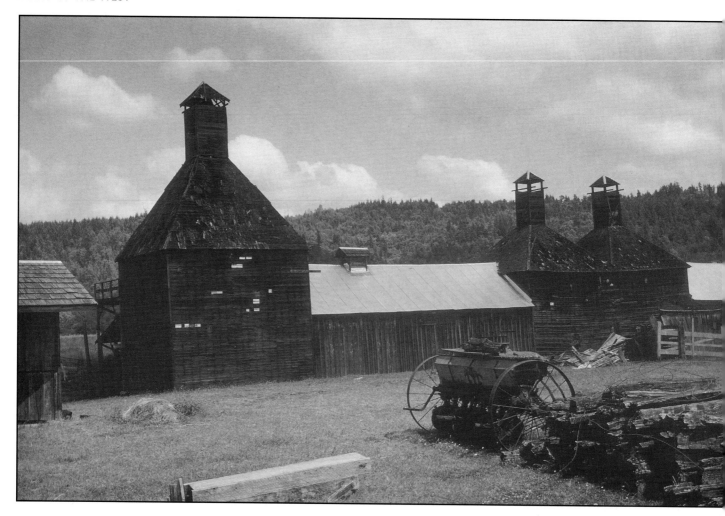

Twenty years ago there were still a dozen hop barns left in Puyallup Valley, Washington. Only a few remain today.

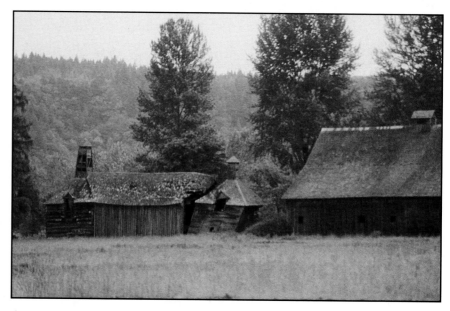

The Woolrey-Koehler hop kiln near Orting, Washington, was nominated to the National Register of Historic Places in 1983. It collapsed in 1993. Its oldest part, of cedar logs, was built in about 1869.

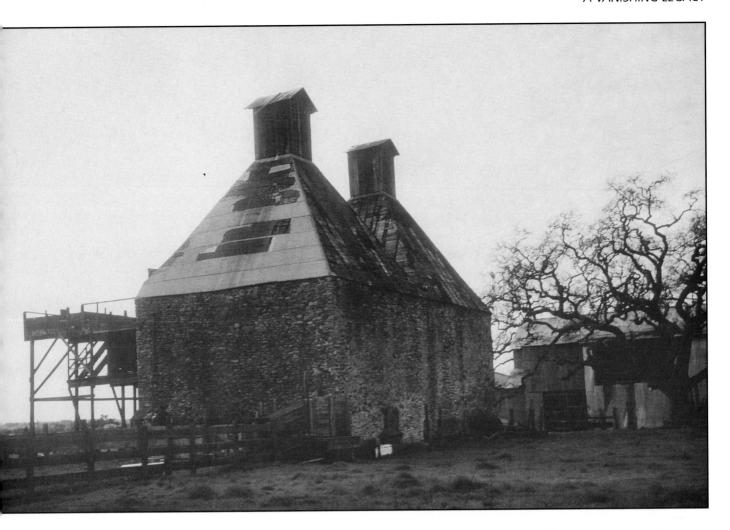

towered drying barns. A wide porch at the
second story drying floor level, often with a
ramp to the ground below, is another feature
of these unique buildings.

With the repeal of Prohibition in 1933,
hop growing resumed, but the new driers
have none of the picturesque characteristics
of the old ones. The tall ventilating towers
have been replaced by long, low clearstory
outlets for the steam, or by low box-like
structures with circular openings for exhaust
fans. Heat is supplied today by furnaces that
burn oil or natural gas, and the hops are
stripped from the vines by machines.

The old tall-towered hop driers are now
obsolete and disappearing fast; even those of
the post-repeal era of the Thirties are now
outmoded relics of an agricultural
technology that continues to change.

*Top: These great stone oast houses
near Santa Rosa, California, are relics
of an era when that state led the
nation in the production of hops.
Very few are grown there today.*

*Above: The furnace under this
California oast house has used several
different fuels over the years. The last
was apparently oil.*

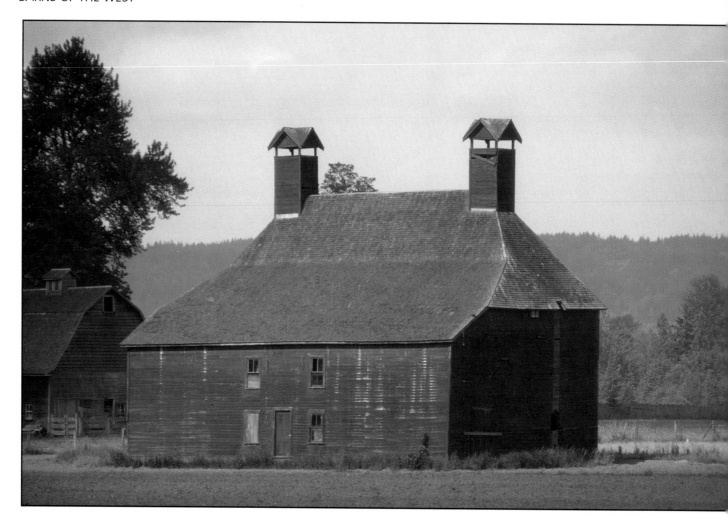

Puyallup Valley, Washington.

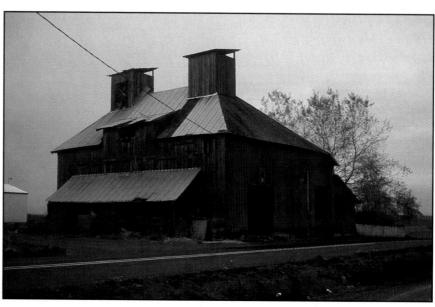

Willamette Valley, Oregon.

The Ahtanum Valley, southwest of
Yakima, Washington, was once a
great hop producing area. Today the
industry is centered in the Moxee
Valley to the east.

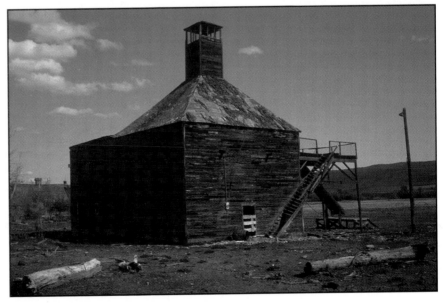

Ahtanum Valley's hop drying barns
are decaying away.

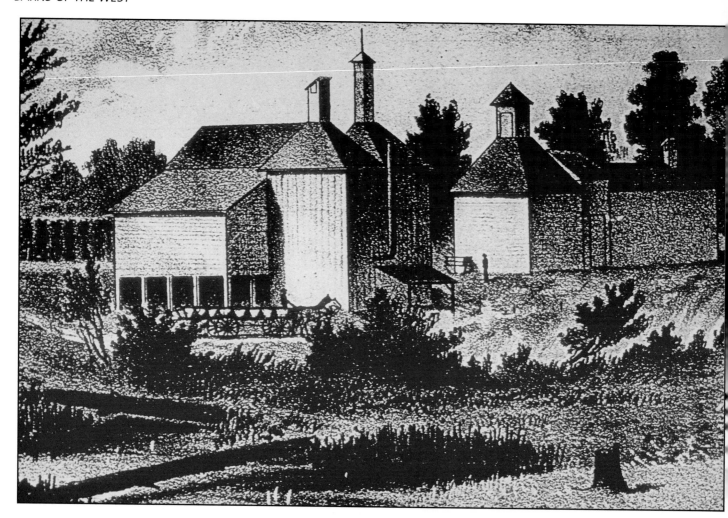

The West Shore *magazine published this lithograph of D.M. Ross's hop farm near Puyallup, Washington, in 1884.*

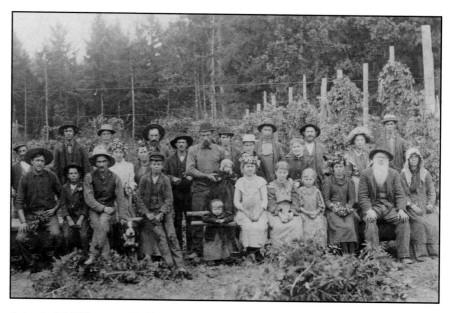

A typical Willamette Valley hop picking crew of the 1890s. Photo courtesy of Wallace Kay Huntington.

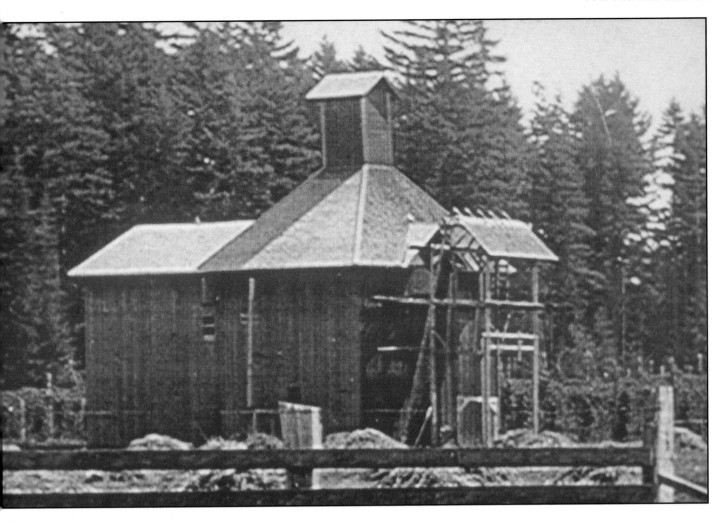

A typical small Willamette Valley hop drier of the 1890s. This one was near Woodburn. Photo courtesy Mike Gooding.

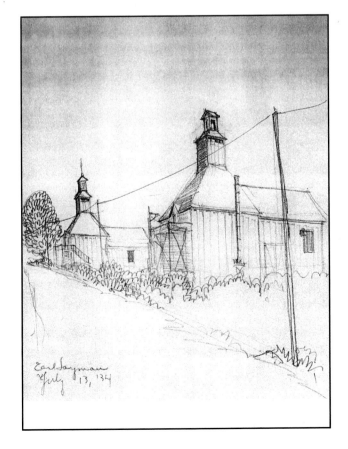

Noted architectural historian Earl Drais-Layman sketched these hop kilns near Champoeg, Oregon, July 13, 1934. Drawing courtesy of the artist.

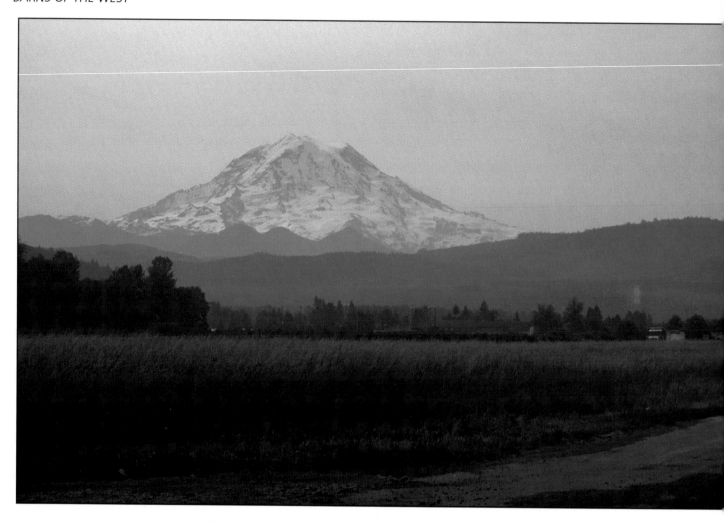

Magnificent Mount Rainier rises in the southeast above the Puyallup Valley. The Puyallup River and half a dozen others have their birth in Mt. Rainier's glaciers.

The ten acre Hart farm, overlooking Puyallup Valley, was a diversified operation: two acres of logged-over woodlot, an acre of orchard, two acres of hayfield, an acre of raspberries, an acre of family garden, and three acres for house, barn chicken house, brooder house, hog house and milk house. The fenced in front yard had a small fish pond.

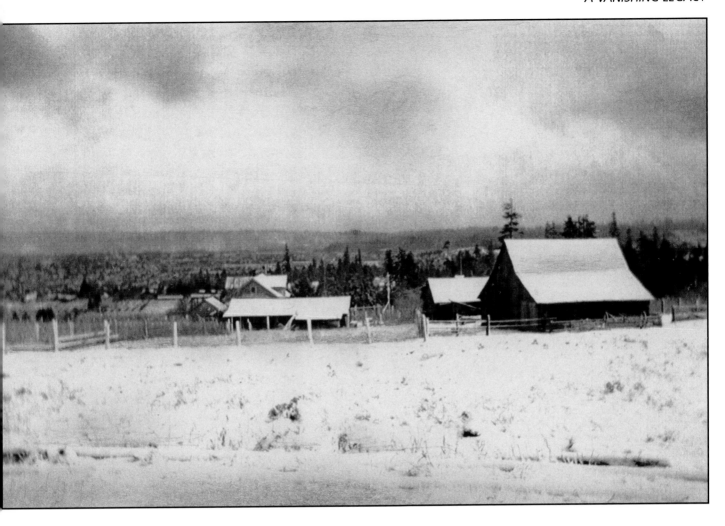

A Personal Epilogue

Who can resist a quickened interest at the sight of a grand old barn, lending its dignity to the rural landscape? I certainly can't, after a lifetime of traveling the backroads. For me, as for most Americans, the barn is a visible link with parents or grandparents who lived on farms. In my case, and for many of you, barns were part of our own lives.

This book is about barns, and not about the author, but these reminiscences may strike a responsive chord with some of you. If you lived on a western farm in the late Twenties and early Thirties as I did, the barn was the economic center of the operation. We farmed with horses, kept cows, hogs and poultry. The barn and other buildings on our farmstead gave essential shelter to the animals and their feed. The greatest disaster that could befall any farm family was the loss of a barn through fire; and the threat was always there.

In the depths of the Great Depression, that national tragedy that shaped the attitudes and lifelong habits of so many of us, thousands of destitute men rode freight trains across America looking for work. The tracks ran past our 80 acre farm near Troutdale, Oregon, and we often had hoboes come to our door looking for work or food. Rarely did they ask for a handout. Most were decent men, down on their luck, some with families far away. They had too much pride to beg. Mother often fed them in exchange for some chore like chopping firewood, weeding the kitchen garden, or picking fruit. On occasion they needed a place to bed down for the night, and asked permission to sleep in our barn. If they promised not to smoke, this was usually

granted. My parents, I realize now, were faced with a dilemma. If they allowed a man to sleep in the barn there was always the risk that he might accidentally start a fire. If they turned him away, there was the danger that he might burn the barn out of spite.

We heard stories from neighbors, or read in newspapers, of vagrants who had burned a barn, or had a bloody fight, or stolen a valuable horse, and once of the finding of the body of a murdered man in a hayloft. These tales all held children's full attention — they were the ghost stories of my rural childhood.

Occasionally, hoboes who dropped off passing freight trains slept in our barn without permission. This was a constant worry to my mother, who tried to keep an eye out for intruders. This wasn't easy as our barn was more than a hundred yards from the house. One cold, wet evening she thought she had seen someone skulking around. When she told my father, he lit a kerosene lantern and went to investigate. The horses and cows were bedded down inside that night because of the rain, and he was concerned about them, as well as the possibility of fire. As he peered into the stalls, holding his lantern high overhead, he felt, rather than heard, the presence of someone in the loft. Deciding to let sleeping tramps lie, he had turned to go back to the house when a three-tined pitchfork, hurled with great force, was driven quivering into the wooden floor at his feet. Being a prudent man, dad lost no time getting out of there. He ran through the damp, dark night back to the house and telephoned the sheriff. Not surprisingly, no trace of anyone was found when the sheriff came by in his Model T Ford half an hour later, but it was a long time before anyone in our family wanted to go into the barn after dark. Our chores often required it, of course, but we always felt a prickly sensation at the backs of our necks, and at the slightest noise we'd bolt for the house. Later, when we had electric lights, the barn was not as scary a place.

Among my barn memories are those of a later farm in Washington, and of cats — black, white, striped and spotted. I never knew a barn without at least one, and usually there were a lot more. Farmers valued them as efficient hunters who kept the rodent population down, saving on grain and damage to harness. Field mice loved to chew leather. Barn cats were also good company, like their more pampered cousins, the house cats. They would gather at milking time, to purr and rub against our legs as we sat down on the stool with the bucket. They wanted us to know they expected their share of the warm milk we would soon have hissing into the pail. Farm lads enjoyed squirting milk at the hungry cats who were quite adept at catching the stream in their dainty pink mouths. Any that missed was soon licked up.

When milking was done, a generous panful was always left for the cats. They were rarely fed anything else, aside from occasional table scraps, for their job was to hunt, and they were good at it. Field mice were their usual prey, although they occasionally caught a robin or a sparrow. No cat could catch a barn swallow, though. That most graceful of flyers regularly nested in our barn, in an unusual place. Although our neighbors' swallows habitually built their mud-cup nests under the eaves, ours built on a crossbeam high in the hayloft. Their only entrance into that big space was through a knot-hole in the outside wall. It was a thrill to watch a fork-tailed, steely blue-black form in full flight whip through the two-inch hole at full speed, folding its wings just enough to clear, and fluttering up to the nest inside. When fledglings were in the nest, the parent birds repeated this feat a dozen times an hour and, with seemingly tireless energy, caught insects on the wing and carried them to their voracious young.

Barns are a wonderful place for hide and seek. As children we found all kinds of secret places, deep in the hay, high in the rafters, in dark corners of stalls, or behind sacks of grain. Sometimes the game was

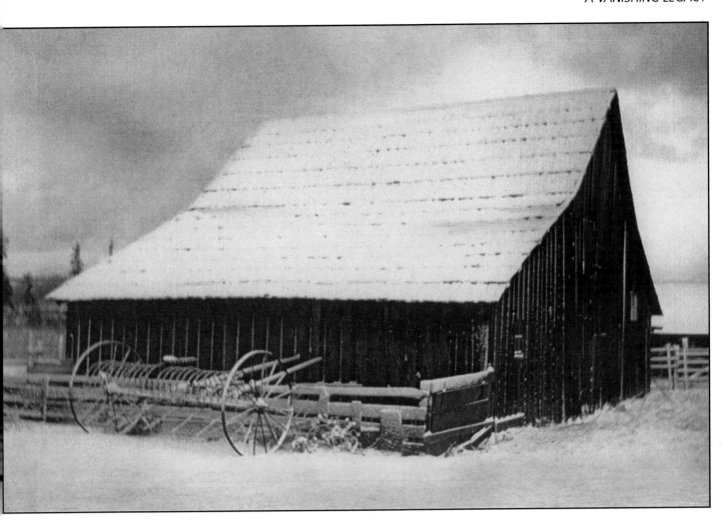

simply to hide and wait for an unsuspecting sibling to come along, and then jump out with a blood-curdling yell. My brother Robert and I played a game of tag that started when one of us yelled, "Catch me if you can." The object then was for the other to take off in pursuit to corner and tag him. The adrenaline flowed as we led each other wild chases up ladders and across high beams, jumping over stall walls or into the hay, running along the top of cattle stanchions, or swinging Tarzan-like on ropes hung for that purpose. Much laughter and shouting accompanied the heart-pounding exercise until we both collapsed in the soft, sweet hay for quiet recovery. We were relaxed and happy then, just experiencing the wonderful twilight space of our old barn, thinking it the greatest playhouse two kids ever had. The smells in an old barn were special too — a blend of hay, manure, harness leather, harness oil, fly spray, and the medicinal balms we used to treat minor animal wounds. One standard lotion applied to cows' udders was found by country wives to be excellent for chapped hands. It, too, had a distinctive aroma.

By the time we were teenagers and had come to appreciate that girls were entrancing creatures, our old barn became the site of new adventures. The barn was a quiet and friendly place for hand-holding, hugging, and awkward kisses, that got better with practice. My wife of more than 50 years and I recall with tenderness summer evenings when she kept me company while I milked the cows. Our children grew up hearing about our courtship, "while watching the moonrise through the manure door." It truly was magical, for on our hillside, overlooking the Puyallup Valley of Washington, that rustic opening could, on clear evenings, give a glorious view of Mt. Rainier, "our mountain," looking like a mound of strawberry ice cream at sunset, or glowing silver in the moonlight.

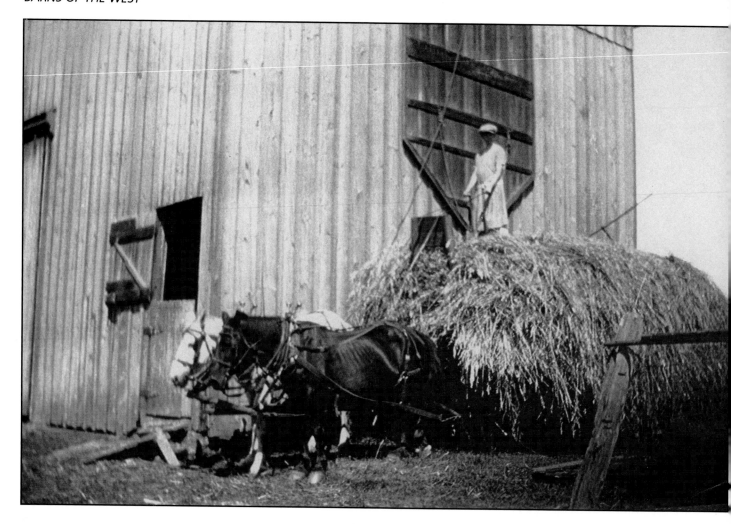

Erma Maltby Hart, the author's mother, bringing in the hay in the summer of 1927. Our 80 acres was near Troutdale, Oregon.

Acknowledgments

No one writing about American barns should fail to pay tribute to Eric Sloane's now classic *An Age of Barns*, published in 1966, following his earlier *American Barns and Covered Bridges*, 1954. Both were best-sellers, and Sloane's crisp drawings made Americans aware of construction techniques and regional types as no previous popular work had.

Although European precedents and East Coast barn history had been extensively investigated and published by 1960, the pioneer work in the West was done by Philip Dole at the University of Oregon. Dole and his students made measured drawings of a number of early Willamette

Valley barns dating to the 1870s. His paper on the Calef barn was published in the *Journal of the Society of Architectural Historians* in 1964. Other articles on western barns were published in the 1970s by Richard Francaviglia, and in 1974 the Oregon Historical Society's ambitious two volume *Space, Style and Structure: Building in Northwest America* included chapters by Dole and the present writer on farm and ranch structures in Willamette Valley and the country east of the Cascades.

Barns of the West: a Vanishing Legacy is the first book to present a pictorial survey of barns in the far western states. It is offered as an overview for the general reader of our

rich heritage in barn architecture: what has been lost, what remains, and what is threatened. Although many thousands of miles of rural roads have been driven by the author and his wife, and more than 3,000 barns have been documented over the past 40 years, no claim to completeness or equal coverage of each state in this vast area is made. The photos selected were those that best illustrated the subjects covered in the various divisions of the book. It should be apparent that each western state deserves a complete overview of its own barn heritage. Hopefully that is already being done or will be done.

The author is indebted to many people for supplying information and encouragement over the years it has taken to compile this book. Grateful acknowledgment is made to:

Robert Aldridge
William C. Anderson
Rick Ardinger
Jennifer Eastman Attebery
Louie Attebery

Donald Hart Baldwin
Gardner W. Barlow
Philip B. Barlow
Linden Bateman
Madeline Buckendorf

Katherine Caron
Ray Chastain
Donald and Lorraine Cochran
Michael and Patricia Cochran
Bill and Virginia Crea
Faye Creason

Helen Rowell Day
Philip Dole
Earl Drais-Layman

Virginia Guest Ferriday

Mr. and Mrs. Bob Gangewer
Kathy Gaudry
Alan Giltzow
Mike and Susan Gooding

Judy Hambley
Wyona Harrold
Fred and Alpha Houston
Charles F. Hummel, F.A.I.A.
Wallace K. Huntington

Bruce and Velma Kock

Mary Lee Lien
Ernest Lombard
Dolores Long
Ruth A. Long
Bob Lorimer

Thomas McClanahan
Wendy McClure
William Bertram McCroskey

Verne and Lorraine Nietert

Marian Posey-Ploss

Lorry Roberts
Bonnie Robinson
Jack and Ruth Rose

Robert Seavey
Carmelita G. Spencer
Susan M. Stacy
J. Merle Stark
Harriet Stephenson

Thomas Vaughan

Betty Penson Ward
Merle W. Wells
Harold West
Dwight and Barbara Williams
Jean Wilson

Special acknowledgment is made of the large part my wife, Novella Dee, had in this project. She was not only a delightful companion on our barn-storming travels, but note-taker, excellent word-processor operator, and editor. Her constant encouragement, patience and dedication made this book possible.

ARTHUR A. HART
BOISE, 1996

Bibliography

Arthur, Eric, and Dudley Whitney, *The Barn: a Vanishing Landmark in North America.* Greenwich, Connecticut: New York Graphic Society, 1972.

Although this is the first major scholarly work of its kind, beautifully illustrated and printed, it should have been subtitled *A Vanishing Landmark in Northeast North America*, since it confines itself to that area and to European precedents.

Endersby, Elric, Alexander Greenwood and David Larkin, *Barn: The Art of a Working Building.* Boston and New York: Houghton Mifflin, 1992.

Like the Arthur & Whitney book described above, this one is magnificently produced. The photography is outstanding. However, no mention is made of barns in western states, nor do any of the photo captions identify the location of the few that might have been taken in the West. There is no index.

Radford, William A., *Radford's Combined House and Barn Plan Book.* Chicago and New York: The Radford Architectural Co., 1908.

A classic example of the kind of professionally prepared plans that farmers could order. Radford and others like him helped improve and standardize American barns.

Rudofsky, B., *Architecture Without Architects.* New York: Museum of Modern Art, 1965.

Schultz, LeRoy, *Barns, Stables and Outbuildings: a World Bibliography in English, 1700-1983.* Jefferson, North Carolina, and London: McFarland, 1986.

This useful bibliography, though far from complete, confirms the fact that little has been published on western American barns. It needs careful editing, i.e., Philip Dole's Calef barn study is rendered "California barns," and Richard Francaviglia is listed as "Francaniglia."

Sloane, Eric, *American Barns and Covered Bridges.* New York: Funk & Wagnalls, 1954.

_____, *An Age of Barns.* New York: Funk & Wagnalls, 1966.

Smith, Elmer L., *Hex Signs and Other Barn Decorations.* Lebanon, Pennsylvania: Applied Arts Publishers, 1980.

Vaughan, Thomas and Virginia Guest Ferriday, Eds., *Space, Style and Structure: Building in Northwest America.* Portland, Oregon: Oregon Historical Society, 1974.

Woodall, R., *Magnificent Derelicts.* Seattle: University of Washington Press, 1976.

_____, and T. Watkins, *Taken By The Wind.* Boston: New York Graphic Society, 1977.

Index

112